Renters Insurance

How to Get the Best Coverage at the Best Price When Someone Else Owns the Place Where You Live

SILVER LAKE PUBLISHING
LOS ANGELES, CALIFORNIA

Renters Insurance

How to Get the Best Coverage at the Best Price When Someone Else Owns the Place Where You Live

First edition, 2002
Copyright © 2002 by Silver Lake Publishing

Silver Lake Publishing
2025 Hyperion Avenue
Los Angeles, California 90027

For a list of other publications or for more information from Silver Lake Publishing, please call 1.888.638.3091. Outside the United States and in Alaska and Hawaii, please call 1.323.663.3082. Find our Web site at **www.silverlakepub.com**.

The Silver Lake Editors
Renters Insurance
Includes index.
Pages: 250

ISBN: 1-56343-767-8
Printed in the United States of America.

ACKNOWLEDGMENTS

The Silver Lake Editors who have contributed to this book are Kristin Loberg, Christina Schlank, Steven Son, Megan Thorpe and James Walsh.

This is the tenth title in Silver Lake Publishing's series of books dealing with risk and insurance issues that face people living in the United States and other developed countries. Throughout this book, we refer to insurance policy forms and legal decisions from the United States—but the spirit of the discussion about risk and insurance can apply beyond the jurisdiction of the courts cited.

Some of the insurance policy language referenced in this book has been developed by the New York-based Insurance Services Office (ISO). ISO policy terms are updated and modified regularly. Our references to the terms are intended solely to illustrate common issues and disputes. You may need to consult with a professional advisor before making decisions about specific insurance policies.

This book is intended to make the concepts and theories of renters insurance and "broad theft" coverage understandable to consumers. The Silver Lake Editors welcome any feedback. Please call us at 1.888.663.3091 during regular business hours, Pacific time. Or, if you prefer, you can fax us at 1.323.663.3084. Finally, you can e-mail us at TheEditors@silverlakepub.com.

James Walsh, Publisher
Los Angeles, California

CONTENTS

TABLE OF

WHY YOU NEED
RENTERS
INSURANCE

Risk is a part of everyday life. Most people—especially young people—avoid thinking about risk until **something bad happens**. The what-ifs get left behind as we worry about more urgent and pressing problems like work, family and money.

> Although bad things happen to good people, many would rather bank on the false idea that nothing bad will happen to them, than plan for misfortune and disaster.

Most would rather put off worrying about what *could* happen, and instead, focus on the now and what *is* happening.

But truth is, you never know what could happen that could **wipe you out financially**. Aside from health and auto issues, other common problems often relate to where we live. Nationwide, close to 68 percent of Americans own homes; the other 32 percent

rent.[1] In cities, those numbers are almost reversed: 69.8 percent of New Yorkers rent; 61.4 percent of Los Angelenos rent; 56.2 percent of Chicagoans rent; and 54.2 percent of Houstoners rent. Renting is easier than owning a home because you don't have to worry about things like a mortgage, property tax, homeowners associations and making home improvements. There are benefits to owning a home (as well as a few pitfalls)...but that's another book.

The focus of this book is on those who rent, because even though renters usually find that they don't have to pay for maintenance, garbage removal, utilities and water, etc., they may find themselves responsible for, well, some **bad luck**. It doesn't matter whether you're renting a town home, a condominium, a bachelor pad, a single-family detached home or a 5,000 square foot penthouse.

> You could return from a business trip and find that everything you owned has been burned by a fire. You could leave the bathtub running for too long and flood your apartment, as well as two units below you. You could be sued by your favorite FedEx delivery man for causing him to slip and fall because he didn't see those boxes you left out in the hallway.

Ask yourself, can I afford to reverse the consequences of something bad happening? Assume you can't rely on anything but your own bank account. Could you replace all those burned items and pay for living some-

[1] The actual numbers, according to National Multi-Housing Council and tabulated from the U.S. Census Bureau's American Housing Survey for 1999, are 67.7 percent and 32.3 percent.

where else until the building is fixed? Could you cover the damage done to your and your neighbors' apartments by the bathtub water (including their ruined personal items)? Could you open your wallet up to the FedEx guy's bill for medical payments, pain, suffering, lost wages and negligence? Probably not.

If, however, you could pay as little as $10 a month and be covered for when the what-ifs happen, you'd probably do it. Even if you think you're at low-risk for having accidents, you can't immunize yourself from someone else's negligence or getting sued for your own **personal liability**. And this is why renters insurance is key.

COMMON MYTHS

You don't have to be renting an historic Victorian in the city or a spacious co-op in a trendy suburban enclave to need some insurance on the place that you live and the things that you own. And you don't need to be an ex-dot.comer, who collected millions before leaving that world to recline in rented manors and collect antiques, to need **protection from sudden losses**.

By the time you graduate from college, you already have enough reason to get some insurance. Although you may not be "worth" that much because you carry debt in the form of student loans and credit cards, you've probably accumulated things that can add up to roughly $30 thousand in **replacement value**. In other words, if you were to inventory your personal belongings and add it all up, that's what those things would be worth to you. It may seem like a lot for someone who is just starting out in life, and who may

not even have a job, but think about all those electronics, CDs, books, cupboard things, appliances, gadgets, clothes and furniture items. If you lost everything overnight, more than likely you wouldn't be able to replace everything overnight and out of your own pocket.

Despite the value of having a renters policy, only **29 percent of renters** have one. Why? There are many reasons, stemming from not knowing what a renters policy is (or even knowing that renters insurance exists), to not understanding how insurance works and what it can do for you. Not comprehending how much money you have in your possessions and what they are really worth to you is the most common mistake. But think again what it would feel like to lose everything in an instant. For those lucky few who spill out of college and land some high-paying job, your **income may be your most valuable asset**. So, if you have a friend come over to help hang blinds, and she falls and breaks her leg, you'd rather have a policy pay for her medical bills than your future income. Some common myths about insurance include:

My landlord has insurance, so if anything happens the landlord is responsible and his policy will cover me. This isn't true. The landlord's policy **covers the physical building, but not your possessions**. Even if the cause of your loss is blamed on the landlord, he won't pay for replacing your possessions. And, if it's determined that a fire or flood, for example, was caused by you—by mistake—then the landlord might come after you in a lawsuit to recover his damages. Liability is another reason not to rely on your landlord's insurance. When someone finds you liable for injuries or damage, you can't rely on your landlord for help.

Insurance costs money and I don't have extra money for things like that. The average cost of renters insurance is $160 per year for around $15,000 in coverage. Some policies cost less, some more. It all depends on how much you own. If you live in a strappy one-bedroom with a computer, TV and stereo, you'd probably pay close to $125 a year. Broken down into monthly installments, that's the **cost of a small pizza**. And, even if you've got a lot to protect and your policy runs you $250 a year (for that rosewood armoire and top-of-the-line road bike), the monthly cost to you is around $20—or the cost of a large pizza. For more coverage, you'll pay more. A policy, for example, that costs $350 a year can give you $50,000 in coverage.

My building has never had a problem and I live in a good neighborhood. For this exact reason, you need a policy. Insurance is a cushion for when the unexpected happens. If your building hasn't experienced a fire, robbery or water damage, then an unexpected event is all the more likely to happen.

Nothing will happen to me. Really? Many like to live risky, but everyone frowns upon having to empty his wallet when something does happen. Renters are responsible for the financial burden of losses created by their own negligence—or by accident in their own dwelling. Apartment **fires and theft** are the leading reasons renters suffer losses. Even when those losses are caused by a grease fire in a neighboring unit, you are responsible for your losses. In this day and age, it's hard to bank on something not happening, or something not happening to someone else, which in turn affects you.

My roommate has a policy, so I don't need one. Not necessarily true. While every policy differs, most will not cover you unless you are listed on the policy. If you are living with someone (or several people) in a unit, you should acquire your own policy for your own possessions if you cannot get added to someone else's policy. Some insurance companies now offer joint polices for cohabitating couples.

I am in college, and under 26, so I am still covered by my parents. Insurance issues get tricky when you reach an age where you're legally an adult but still under the care of your parents for certain things like health and car insurance. If your parents have a homeowners or renters policy, their insurance might give your coverage in the dorm, but not if you live in an apartment. Check with your insurance agent before assuming anything.

I really don't own enough to justify getting a policy. Again, think about what it would cost to replace all of your possessions—even if those possessions originally came from your parents, your Aunt Lynda or the Salvation Army. If having a policy for your possessions doesn't appeal to you, at least think about having a policy to cover your liability. You can't control who will sue you...as the case below reveals.

A CASE IN POINT

Melissa Cantor[2] and her best friend, Annie Atkins, graduated from an East Coast college, moved out to California and found a great condominium to rent in trendy Santa Monica. The unit was one of six, each

[2] Names have been changed here and throughout much of this book on request. These cases serve as examples only and do not reflect outcomes in all cases.

separately owned. It was their **first renting experience**, and they were moved in by October.

At the suggestion of Cantor's stepfather, who happened to be an insurance agent, she took out a renters policy with her auto carrier. According to Cantor, had her stepfather not mentioned a renters policy, she never would have known about it. "I didn't even know what that was at the time."

Before the furniture arrived, the girls **received a letter under their door** from their neighbor in the adjoining unit, Gerry Bushnell. He insisted that they move out; and he offered to pay for all of their moving costs. The landlord had warned the girls about this particular man: "Gerry has a lot of allergies, so be careful when you have guests over who smoke, of if you're grilling or painting...or things like that," their landlord had said.

Neither one of the girls smoked, nor did they have wild parties. They had full-time jobs and used their unit as any renter would. They were not about to move out so quickly, even though Gerry believed that their moving in "wasn't a good idea," according to his letter. Cantor and Atkins learned from the other occupants in the building that Gerry **wasn't a nice guy**. Even though he had a law degree from a top school, people noted he was freakish. He'd cover his windows with aluminum foil, wear a facemask whenever he left the building and make sure that every piece of skin was covered (i.e., he'd wear long socks). Deliveries at his doorstep would remain there for days.

One month after they moved in, Cantor and Atkins received **another letter** from Bushnell, this time tell-

ing them not to use the dishwasher in the evening or early in the morning. He further told them not to wear shoes while inside because they make noise on the hardwood floors.

The girls acknowledged the letter, spoke to their landlord again, and believed that they weren't acting any differently from a typical dweller. They used the dishwasher at legitimate hours and were quiet. In all, they were good tenants.

In January, a knock at the door came with papers, serving them with a lawsuit. Among the allegations: Cantor and Atkins infringed upon Bushnell's right to use his apartment; and housing discrimination. He also **sued the landlord and the homeowners association**. Specifically, the suit revolved around Cantor and Atkins's **personal care products** (i.e., perfume, scented toiletries, etc.), which floated out of their window and into his apartment. Neither Cantor nor Atkins used aerosols, hair spray or toxic chemicals. (The one time they needed to paint a table, they had taken it around the block.)

When Cantor and Atkins turned to their landlord, they were surprised to learn that her policy didn't cover them. However, because Cantor had purchased a renters policy, they managed to file a counterclaim in response to the suit and successfully defend themselves.

In fact, the girls didn't have to do much once the insurance company took over; it handled all the paperwork and the legal gymnastics, representing Cantor and Atkins in court. It took a long year, but eventually the **case was thrown out** of the courts. "If it hadn't been for my policy, I don't know what I would

have done. I was just out of college; it was my first renting experience, and I didn't have any money to deal with a lawsuit—frivolous or not," Cantor said.

You wouldn't want running into a person like Bushnell to be your wake-up call to a renters policy—or any protective insurance policy for that matter.

WHAT IS RENTERS INSURANCE?

Renters insurance is a form of homeowners insurance for renters. It's also called an **HO-4 policy** and it covers the cost of replacing personal property in the event of a loss from fire, natural disaster or robbery. If someone else injures himself while in your rented unit and needs medical care, the policy would help cover those costs. And, if you are sued for negligence, the policy would defend you; if you are found liable, the policy would provide some coverage for what it takes to get you back to where you started—before the problems arose.

> Just because you don't have a million dollars doesn't mean you can't be sued for a million dollars or more. Suddenly, everything is gone—savings, future income, your personal property and your peace of mind.

Renters insurance is available from most property and casualty insurance companies. Some confusion comes from the fact that the coverage is called different things by different companies—the **contents broad form**, broad theft coverage or **tenants insurance**—but,

whatever it's called, the coverage is inexpensive enough
to be worth a look from just about any renter.

Two other important things a renters policy covers,
which most people don't think about, are:

1) the loss of property when it occurs away
 from your apartment, such as gold clubs
 or a bicycle stolen out of your car; and

2) temporary living expenses should you be
 displaced from your apartment while the
 building is being fixed, or aired out for
 smoke damage.

Most policies offer limited coverage for temporary
living expenses. This is also called the **loss of use** or
additional living expenses clause. The policy will
cover expenses above and beyond your usual living
expenses. If, for example, your rent is $1,250 a month
and it costs you $2,500 to stay in a hotel for three
weeks, you would be reimbursed $1,618. The bal-
ance of $882 would be deducted as your typical liv-
ing expense.

You policy might set daily limits to this loss of use
clause. While you may not be able to live at the Ritz
Carlton while waiting for your shoebox to be repaired
from a small fire, some policies allow for reasonable
expenses such as meals and travel. This is when know-
ing the exact terms of your policy is important, and
asking about the specific details (e.g., length of time
and amount) of its allowances. Some companies of-
fer **fair cost** limits, in which case you are covered for
maintaining your normal standard of living in a relo-
cated spot, not to exceed X number of months.

If a fire puts you out of your rented unit, and you can't even fetch your wallet out of the flames to pay for a new toothbrush and clean underwear, a check or cash can be delivered to you by the insurance adjuster or agent right away to help pay for such necessities on the spot. This is also called *loss mitigation.*

It doesn't matter who caused the fire or where the flood started; regardless of the problem's origin, you will have to file the claim to your own insurance company. If the source of the fire or flood was in a neighboring unit, you will need to rely on your own policy for help. Your company will try and get reimbursed from the company of the policyholder who is responsible for the damage—if such a policy exists. If your neighbor doesn't have a policy, then the most you'll have to pay is your **deductible**. It may not seem fair to have to pay a deductible when someone else caused the damage, but at least you're covered on your end and you don't have to worry about getting someone else to help pay for your damages. Your insurance company will do everything it can to get money from the neighbor.

The only way you'll get out of paying your deductible is if your insurance company succeeds in getting that money back from the neighbor's insurance company or if a miracle happens and your neighbor feels sorry for you...and he gives you the money.

Throughout this book, we'll go into the finer details of a renters policy. It's important to keep in mind that this is a policy **for your possessions and liability**. You do not need to insure the building in which you live. And, if you don't want to pay for liability protection (which isn't a good idea) you can opt for a policy that covers only personal property.

DEDUCTIBLES

When you file a claim, you can't expect an insurance company to pay for 100 percent of the costs related to damages. This protects the insurance company from frivolous claims and makes you responsible for a portion of the damage. If, however, you are found not liable nor at fault for an event, your company may reimburse you for the deductible if it can recover that deductible from the policyholder who caused the damages.

Deductibles for renters insurance differ depending on your policy and the amount of your premium. The standard policy has a $250 deductible, but you could find a policy with a deductible as low as $100 or as high as $500 or $1,000.

The general rule with it comes to deductibles: The higher the deductible, the lower the premium. If you want a low premium, you'll have to pay a higher deductible if and when something happens. For this reason, it's important to balance your ability to cover the deductible with the monthly premium savings.

Deductibles make it pointless to claim certain things. For example, if you have a $1,000 deductible, it doesn't make sense to put in a claim for the destruction of your $1,000 couch from a wine party or water damage to your $600 leather coat when the pipes in the wall by a closet froze and burst. If you must pay $1,000 first before your policy kicks in, there's no reason to claims these items. Remember: policies don't kick in unless a claim is for more than a deductible.

In many cases, a person's most valuable asset is a computer. So, if you get home one day and your $2,000 computer is gone, and your deductible is $250, the insurance company will cover you for $1,750. We'll talk more about this later, however, because depending on the value of your electronics or other expensive assets, you may have to obtain an **endorsement** or **rider** for these items in addition to your basic policy. And this is when the difference between replacement cost and actual value is key.

CASH VALUE VS. REPLACEMENT VALUE

There's a big difference between these two kinds of renters insurance:

Cash value coverage pays for what the property is worth at the time of the loss. If your policy is for actual cash value of your possessions, then you will get the value of your assets minus depreciation. Thus, your three-year-old computer and five-year-old couch will be valued much less than what it will cost you to replace those items. And you insurance company will evaluate what those items were worth when they were damaged or stolen before writing you a check.

Replacement cost coverage pays for what the items cost to replace in today's market. So, if you have this kind of coverage, your insurance company will pay what it takes to replace your losses. You can go and buy a new computer and new couch (of similar kind and quality to your originals) and the insurance will cover the complete current cost of buying those items. This coverage is more expensive, but it's considered a bargain among industry experts. For a few dollars more a year you can have replacement coverage and not worry about being unable to completely replace your losses. Some companies offer only replacement value coverage, or quote this coverage by default.

Deductibles still apply to both kinds of coverage. The monetary difference between buying a cash value policy and a replacement value policy is minimal when compared to the difference between what these two policies mean to you as a consumer. If you lose your possessions, you wouldn't want to replace those possessions with second-rate items, affordable only because your policy gave you cash value. You'd want coverage that would allow you to go out and replace your possessions in the current market. For example, if a fire melts your entertainment center, you'd want a new one rather a check for what yours was worth when the fire destroyed it. This is why agents suggest that renters choose replacement cost coverage.

RENTED HOUSES

You don't have to rent an apartment to need a renters policy. If you are renting anything—a condominium,

a home, a studio, even an illegal unit—you should consider a renters policy. Stories of lessons learned the hard way go something like this: You rent a home and think that your landlord's homeowners policy covers you...and then you return from a trip and find that your place has been ransacked. Your possessions are half-gone, half-destroyed, and you beg the owner of the property to replace all of your stuff— because you think that the broken front gate caused the break-in—all to no avail.

Never rely on someone else to protect you and your possessions. A property owner will have property coverage for the actual building, but not for your own personal things. And if you do something stupid in your rented home, for which you are found liable, you'll want to have that coverage to help out. Otherwise, you'll be seriously out of luck and out of a place to live.

ACTS OF GOD

Another lesson often learned the hard way relates to acts of God, which most polices exclude from coverage unless you ask for these to be specifically included. Typically excluded (or insufficiently covered) from homeowners policies, for example, is coverage for **floods and earth movements** (i.e., earthquakes, landslides, earth sinkings, etc.). Even the coverage for fires have very particular terms to them. Homeowners must ask for additions to their policies if they want these things covered—or covered more sufficiently. And renters must do the same.

Under a basic policy, coverage for personal property can include losses caused by the followed **named perils**:

- fire or lightning;

- windstorm or hail;

- weight of ice, snow or sleet;

- explosion;

- aircraft and vehicles;

- smoke;

- sudden and accidental tearing or bulging of heating or cooling systems;

- theft, riot or civil commotion;

- falling objects;

- volcanic eruptions;

- broken glass;

- artificially generated electrical discharge;

- vandalism or malicious mischief;

- sudden and accidental water discharge from plumbing or appliances; and

- freezing of plumbing systems.

But coverage for earthquakes and flood are separate. In Chapter 6, we'll look at how insurance for earth movement and serious water damage is handled. The point here: Renters must be careful to **read their policies for exclusions**. If, for example, you live on a riverbank or close to an area where hurricanes are a sure thing every year, you might find that a basic policy won't cover you for losses that arise from these events, and that you may have to seek additional coverage under an **endorsement**. It's nearly impossible to acquire flood insurance from any commercial insurance company. Flood insurance is available through the

federal government's National Flood Insurance Program, which works with insurance companies to insure customers. Earthquake insurance works similarly.

> Take the experience of Kim Lewis, for example. In 1999, the 32-year-old woman returned to her rented house by boat after Hurricane Floyd whipped through. When she called her insurance company, she discovered that her renters policy didn't include flood insurance. Thousands of dollars worth of ruined clothes, appliances, electronics and other personal belongings wouldn't be replaced by the insurance company.

When flood insurance is offered on a basic renters policy, it's usually limited to floods that result from broken pipes and accidental discharges or overflows of water. You'd also be covered if a flood results from a fire, explosion or theft. We'll go into more detail later about these types of exclusions and inclusions of a renters policy. For now, it's important to note that policy terms can make a significant difference.

ADDITIONAL COVERAGE

As mentioned above, if you need additional coverage for items not included on your basic renters insurance, you must obtain specific endorsements to your policy. These are also known as riders or **floaters**.

Endorsements, floaters or riders are like amendments—they add coverage or conditions to standard insurance policies. You may need these for special items like jewelry, furs, fine arts, sterling silver flatware, antiques and other collectibles. If you own pricy electronics, such as a computer are worth more than $5,000, you'd probably need a special floater for that, too.

In Chapter 3, we'll discuss how you go about listing your personal possessions and determining how much coverage—and what type—you would need. Basic policies will either not cover some special items, or they will limit their coverage. If you own a 2.5-carat engagement ring worth $20,000, you'd want to get a **personal articles floater**, also called a **personal property endorsement** to cover that ring. Otherwise, your basic policy will only cover the standard $1,000 or so. And, if you own a lot of expensive jewelry, you'll need to ask about what the aggregate limits to your policy are. In many cases, there are limits for any single item, as well as limits for aggregate losses. If you lose an entire jewelry box full of watches and precious and semiprecious stones, don't look to your basic renters policy for help. More than likely, it will cover you for no more than a few thousand dollars without a floater. Also in Chapter 3, we'll go into great detail about floaters and how you can best insure your special possessions.

KNOW YOUR LIMITS

As with exclusions, know what your limits are on your policy. These are clearly indicated on the **Declara-**

tions Page of your policy, typically the first page of the document. The declarations page will include the following:

➡ Important Notices;

➡ Coverages (both property and liability);

➡ Options;

➡ Credits;

➡ Deductible(s);

➡ Annual Premium; and

➡ Other Forms Applicable to the Policy.

Under *important notices*, the policy will say something like: "Your new policy is effective January 15, 2002. **This policy does not provide earthquake coverage.**"

Under *coverages*, there will be a simple outline describing the terms to your renters policy. This is where your **limits are listed**, for both your personal property and liability coverage.

Although the average cost of renters insurance is $160 a year for $15,000 worth of personal property coverage, this isn't a good estimate because each and every policy differs. A basic policy for living in a nice part of town (where theft is also prominent because of all those nice possessions) may set personal property limits around $15,000 and personal liability limits around $100,000 for $260 a year. If you think you need more coverage, ask for more.

It's always easier to pay a little more a year for greater coverage with higher limits than to pay out-of-pocket expenses for a major loss when it occurs and you've exceeded your limits.

Whether you've chosen a cash value policy or a replacement cost policy will be indicated under *options*, or a similar heading on the declarations page. Any credits applicable to your policy will be shown. As we'll see later, you can **get a discount** (sometimes 10 percent) for having a renters policy with the same insurance company as your auto or other insurance.

Also included on your declarations page is your deductible. This may be shown as a percentage of your coverage or as a flat-out dollar amount.

Finally, your **annual premium** will be clearly marked. Any other policy forms that apply will be listed briefly by their form number, and shown in detail on following pages.

RENTERS AND THE CITY

Renters comprise the vast majority of city-slickers. From high-rent zones to low-rent districts, cities abound with all types of renters. And they all have something to protect. Throughout this book, when we refer to policies, we are talking about the basic HO-4 form. Although we will mention other types of policies, such as a dwelling-only policy, HO-6 form for condominium owners and HO-8, or **modified basic form**, if you're a renter, you really only need to concern yourself with the HO-4 broad tenant form.

In the early 2000s, as mortgage rates decreased and purchasing power increased, people started snatching up real estate right and left. Homeownership in the U.S. by the end of 2001 was 67.5 percent. But there are still a great many renters out there who, instead of buying homes and garden hoses, have been buying a lot of stuff—all of which deserves some attention.

CONCLUSION

Perhaps the most valuable thing that a renters policy can provide is **peace of mind**. You don't have to worry so much about the perils of everyday life. This chapter has touched upon some of the reasons why you need renters insurance, and what this kind of insurance can do for you. In this book, we'll go into greater detail about the mechanics of renters insurance, what every term in a policy means and how you can best prepare yourself for dealing with some of life's misfortunes. We'll also provide some general advice for renting, from choosing a decent place to managing your manager.

The next chapter will focus on the mechanics of a renters policy. Then, in Chapter 3 you'll find some tools you can use to determine the kind of coverage—and just how much coverage you should buy for yourself. It all comes down to how much your possessions are worth.

2

CHAPTER

THE MECHANICS OF
A RENTERS POLICY

Coverage for some of the **perils of life** is important, even for renters. Because of the importance of renters insurance, landlords will sometimes require that their tenants carry some form of this insurance. This is particularly the case when it comes to luxury apartments or, conversely, rent-controlled units. In states with large urban centers, however, insurance and housing regulators have outlawed these requirements in the name of consumer protection.

> Cities that prohibit landlords from requiring their tenants to carry renters insurance send the message to people that it's a rip-off and unnecessary. Renters insurance is quite the opposite: cheap and valuable at the same time.

Renters insurance can either be written in a **comprehensive form** for all risks that aren't explicitly excluded or for **named perils only**. Named perils coverage averages about 20 percent less expensive, because the losses it covers are more limited. Even in-

surance written on a named perils basis should cover fire, theft or water damage. These are primary hazards renters face.

Although it doesn't cover the building itself, an HO-4 policy provides a limited amount of coverage for building additions and alterations. This is also known as **leasehold improvement insurance**. What does this mean? If you spend money to improve the apartment or house you're renting, the renters insurance covers the investments you've made in the place. You'll probably find this under "additional property coverages" and, more specifically, "building additions and alterations," in your policy. Your insurance company will cover any building additions, alterations, fixtures, improvements or installations, made or acquired at your expense. But the limit of liability will not exceed 10 percent of the typical limit of liability for your personal property. And this is just one of many specific coverages detailed in your policy. In this chapter, we'll review the mechanics of a basic renters policy and get you acquainted with what a renters policy really looks like...as well as what it means.

THE BASICS

All personal property is insured against loss by the **broad form perils** under an HO-4 policy.

Homeowners form HO-4 may be issued to any of the following:

- a tenant non-owner of a dwelling or apartment;

- a tenant non-owner of a mobile home;

- an owner-occupant of a condominium; or

- an owner-occupant of a dwelling or apartment when not eligible for coverage under one of the combined building and contents homeowner forms.

Renters policies are purchased most often by renters of apartments, dwellings or condos who do not require the complete range of coverages—liability coverage, swelling structure coverage, etc.—provided by the other standard homeowners forms.

> Renters rarely have to be insured for the building itself. And renters who don't want to pay for liability protection can opt for a policy that covers only personal property...but this isn't recommended.

INSURING AGAINST THEFT

One reason that renters insurance is so attractive is that it covers personal property against theft.

> By comparison, basic dwelling policies do not provide any theft coverage for personal property. A broad theft coverage endorsement has to be added to a dwelling policy—at additional premium—to provide such coverage.

For many insurance companies, the **broad theft coverage endorsement**—sold in a slightly different version as stand-alone insurance—is renters insurance.

Theft coverage provides insurance against loss by the following two perils:

- **theft**, including attempted theft; and

- **vandalism and malicious mischief** as a result of theft or attempted theft.

A caveat: The vandalism coverage won't apply if your residence has been vacant for more than 30 consecutive days immediately before the loss. In most cases, though, this limit won't be an issue for renters.

By comparison, basic dwelling policies do not provide any theft coverage for personal property. A broad theft coverage endorsement has to be added to a dwelling policy—at an additional premium—to provide such coverage.

Broad theft policies (or endorsements) contain three definitions that affect the coverage:

- **business** means any trade, profession or occupation,

- **insured** person means the named insured and residents of the named insured's household who are either relatives of the named insured or under the age of 21 and in the care of any insured person,

- **residence employee** means an employee of any insured who performs duties related to maintenance or use of the described location, including household or domestic services, or similar duties elsewhere which are not related to the business of any insured person.

Property used for business purposes isn't considered personal property and, therefore, isn't covered.

Only property that belongs to an insured person is covered—so, if the $2,500 camera you're keeping for a friend gets stolen from your trendy downtown loft, you may have some explaining to do.

Finally, property of **residence employees** is covered only if you ask the insurance company to add language saying so. This may raise your premium—though many companies will add the coverage for no additional cost.

A **limit of liability** must be shown for on-premises coverage. This limit is the most the insurer will pay for any one covered loss at the described location. On-premises coverage applies while the property is:

- at the part of the described location occupied by an insured person;

- in other parts of the described location not occupied exclusively by an insured person, if the property is owned or used by an insured person or covered residence employee; or

- placed for safekeeping in any bank, trust or safe deposit company, public ware-

house, or occupied dwelling not owned, rented to or occupied by an insured person.

This type of insurance limits coverage either with one **general dollar limit or a range of dollar** limits applicable to different types of personal property. In the first case, a policy would insure all your property—regardless of type—to a limit of $30,000. In the second, a policy would insure computer equipment up to $5,000, stereo equipment to $2,500, sports equipment to $2,000, etc.

Although limits of liability are shown for the maximum amount of insurance for any one loss, special **sub-limits of liability** usually apply to specific categories of insured property. Each limit is the most the insurer will pay for each loss for all property in that category.

Although we'll go into greater detail of these limits in Chapter 3, examples of the special limits of liability might be:

- $250 for money, bank notes, bullion, gold and silver other than goldware and silverware, platinum, coins and medals;

- $1,500 for securities, accounts, deeds, evidences of debt, letters of credit, notes other than bank notes, manuscripts, passports, tickets and stamps;

- $1,000 for jewelry, watches, furs, precious and semiprecious stones;

- $2,000 for firearms; and

- $3,000 for silverware, silver plated ware, goldware, gold plated ware, and

> pewterware, including flatware, hollow-
> ware, tea sets, trays, and trophies.

Limits similar to these are found on homeowners policies. The intent of the policies is to provide **basic coverage** for special items of value that may be subject to theft losses. However, some people collect particular items and may have **disproportionate exposures** not contemplated in average insurance rates. Most policies will not allow the full limit of liability to be applied to a specific kind of property.

If you have greater exposures, higher limits may be available for an additional premium charge, or a separate personal property floater may be purchased (see Chapter 3).

In some cases, **off-premises theft coverage** is available. Off-premises coverage applies while the property is away from the described location if the property is either:

- owned or used by an insured person, or

- owned by a residence employee while in a dwelling occupied by an insured, or while engaged in the employ of an insured.

Example: If you ride your $4,000 mountain bike from the houseboat you're renting to the mountains north of Seattle—and someone steals it while you're waiting to pay for a cafe lattè—the insurance company will get you a new bike.

A number of **conditions** apply to off-premises coverage:

- you can only buy it if you've bought **on-premises coverage**;

- a **separate limit of liability** must be shown for off-premises coverage (this limit—usually lower than on-premises limits—is the most the insurer will pay for any one loss); and

- off-premises coverage does not apply to property that you move to a **newly acquired principal residence**. That last point is a considerable issue in renters insurance.

One way insurance companies shield themselves from the volatility that sometimes accompanies the renter's lifestyle is by limiting the **transferability** of a renters policy from one location to another.

If you move during the policy term to a new **principal residence**, the limit of liability for on-premises coverage will apply at **each residence and in transit between them** for a period of 30 days after you begin to move the property. When the moving is completed, on-premises coverage applies at the new described location only.

For a list of property not covered by a renters policy, such as birds and credit cards, refer to Chapter 3.

WHO IS AN INSURED?

The definitions page of a policy identifies the person insured by the policy (called the **named insured**) and

other people insured at the request of the named insured. This portion of the policy may include the following language:

> Insured means you and the following residents of your household: a) your relatives; and b) any other person under the age of 21 who is in the care of any person named above.

Under Section II, Liability Coverages, "insured" means:

> with respect to animals or watercraft to which this policy applies, any person or organization legally responsible for these animals or watercraft which are owned by you or any person included in a or b. A person or organization using or having custody of these animals or watercraft in the course of any business, or without permission of the owner is not an insured;

> with respect to any vehicle to which this policy applies, any person while engaged in your employment or the employment of any person included in a or b, or any person using the vehicle on an **insured location** with any insured's permission.

Refer to Chapter 5 for more definitions, particularly the definition of **insured location**.

If any person named in the Declarations or the spouse, if a resident of the same household, dies, the insurance company will insure the legal representative or the deceased, but only with respect to the premises and property of the deceased covered under the policy at the time of death. Here, **insured** includes:

1) any member of the household who is an insured at the time of your death, but only while a resident of the residence premises; and

2) with respect to your property, the person having proper temporary custody of the property until appointment and qualification of a legal representative.

Other language you might encounter includes:

Upon the request of the named insured, the personal property of others may be covered while on the residence premises, and the personal property of guests or a residence employee may be covered while in any residence occupied by an insured.

A residence employee means an employee of any insured person who performs duties related to maintenance or use of the residence premises, or who performs household, domestic or similar duties elsewhere that are not connected to the business of any insured person.

THE LIVE-IN OR "SPOUSE"

It's important to understand the definition of *insured* when it comes to your policy's coverage. If you have roommates, it's a good idea to add them to your policy or, depending on the type of policy you have, suggest that each one of your roommates obtains his or her own policy. Sometimes the insurance company will allow you to add names to your policy, while

some companies want everyone to have a separate policy.

And if you live with someone—out of wedlock—things can get particularly tricky. You might think that your significant other qualifies as a "spouse" as defined in the policy, but in reality, he or she does not.

> Even if you've been living with your girlfriend or boyfriend for 15 years, share all the bills and rent, you cannot assume that your renters policy includes your significant other as a covered insured. Erroneously read exclusions can cost you a lot of money.

The 1996 Louisiana State Appeals Court decision *Steven G. Crigler vs. David Crigler, et al.*, shows the importance of knowing the definition of an "insured."

Sherry Johnston and David Crigler lived together for about 13 years before co-leasing a house together. Prior to moving to this house, Sherry acquired a renters policy issued by Allstate which was updated when they moved. Sherry was the sole insured of this policy.

David's brother, Steven, visited Sherry and David in July of 1993. One night, the two brothers embarked on an evening of drinking and stumbled home at 2:00 A.M. The brothers watched TV and continued to drink before David decided to cook french fries for a late night snack. He put grease in the pan, turned on the stove, and went back to the living room where he fell fast asleep.

Moments later, he awoke to the sounds of fire. As he attempted to douse the flames with water; he splattered hot grease on the floor.

Steven, who had also fallen asleep, woke and ran barefoot into the kitchen, where he slipped and fell into the grease—sustaining severe burns to his feet, ankles, arms and back. Sherry was awakened by the sounds of David putting out the fire. At this point, Steven had already sustained his injuries.

Steven brought suit against his brother, Sherry, and Allstate. Allstate denied liability on the part of Ms. Johnston and denied that the policy covered David Crigler.

David and his brother argued that Sherry had known that they had been drinking, that David liked to prepare late night snacks, and that he enjoyed fried foods. So, they argued that it was her duty to warn Steven of the reasonably foreseeable hazards posed by David's behavior.

The court ruled that the brothers were fully aware of David's alcohol consumption, especially since they purchased a six-pack of beer on the way home. The court also ruled that both brothers were awake when David began his ill-fated cooking attempt. Moreover, as a trained chef, David was familiar with the stove, the hazards posed by grease fires, and the proper method to extinguish such a blaze.

Based on these facts, the court ruled that Ms. Johnston owed no duty to warn Steven Crigler about potential hazards related to his brother's behavior.

The Crigler brothers also claimed the policy was ambiguous because it failed to define, the term "spouse" and that it should include non-marital relationships. The brothers also alleged that Allstate had accepted payments from a joint checking account with David's and Sherry's names and that the Allstate agent knew the couple lived together out of wedlock.

Allstate argued that Sherry was the only "named insured" of the policy. Sherry Johnston and David Crigler were not married and David was, therefore, not Sherry's spouse, nor her relative or a dependent under her care. Under these terms, the judge concluded that David was not an insured.

The court ruled, that "while modern society tolerates many forms of inter-personal relationships, we do not feel that acceptance is wide enough to warrant the judicial expansion of the term "spouse" to include one's paramour or concubine, regardless of the merits or stability of the relationship."

> The term "spouse" implies the existence of a legally recognized marriage and does not lend itself to use as reference to partners living out of wedlock.

The term "spouse," as used in the policy, was not sufficiently broad enough to include David. Furthermore, the common meaning for the term "spouse" is sufficiently uniform to preclude confusion and is not susceptible to multiple interpretations.

In Chapter 7 we'll take another look at the fuzzy me-
chanics of cohabitating couples who want joint in-
surance but can't seem to get it. It's getting harder to
find insurance companies that will write one policy
for cohabitating couples. Often, it's best to get two
separate polices to cover two "separate" sets of prop-
erty. But more on that topic later. For now, we'll get
back to the mechanics of a policy's form.

SECTIONS OF A POLICY

A renters policy is pretty basic in form, similar to the
format of a general homeowners policy. The Decla-
rations Page typically opens the document, followed
by a Table of Contents that includes:

- Insuring Agreement;

- Section I: Property Coverages;

- Section II: Liability Coverages;

- Property and Liability Conditions;

- Policy Definitions; and

- Optional Coverages.

Some of these sections get broken down further. For
example, within Section II you'll find detailed sec-
tions on liability losses the company covers and those
it does not cover, as well as explanations for personal
liability and medical payments.

For more about policy definitions, turn to Chapter 5.
In that chapter, we explain many of the most basic
words encountered on a policy. You may not find
optional coverages in a basic policy, but for those
with the need for additional coverages (e.g., flood,

earthquake, riders or endorsements for special property) this is an important section.

Typically found in renters policies is a section for "special provisions" that pertain to the laws in your state. You may, for example, be mandated by law to have coverage for workers' compensation with respect to residence employees. This is the case in California. Other states may have mandated coverage for other things.

Insurance companies typically use template forms for every state, but will tailor their policies for each state to fit various provisions and laws. Insurance companies operating in different states may also choose to define terms differently or edit the template form to meet certain criteria. A policy's **loss of use** coverage, for example, may read one way in the first section of the policy, but be changed under the special provisions section later in the policy. Another example: A basic policy may state that it does not cover *property of roomers, boarders and other tenants not related to any insured*. However, under the special provisions section, that line may be edited to read, ...*property of roomers, board-ers, **residents** and other tenants not related to any insured*.

The lesson here is to read every line of every policy carefully. You may think you have coverage for something based on the main section of the policy, only later to find the coverage is voided under special provisions.

DECLARATIONS PAGE

The first page of your policy contains the **Declarations**, which outlines the type of policy you have and gives the following information:

1) Insured: name of insured(s).

2) Residence premises: the address to the insured location.

3) Policy number; policy period; and agent's information (if applicable).

4) Important notices: a notice may include the effective date of the policy and whether or not the policy includes extra coverage, such as earthquake.

5) Coverages: the sections of the policy are outlined here.

6) Options: whether you choose replacement cost or actual cash value, for example.

7) Credits: includes discounts you receive on your premium (you may be able to save 10 percent, for example, if you have an auto policy with the same insurance carrier).

8) Deductibles: this figure is shown either as a percentage or an actual amount.

9) Total annual premium: the cost of the policy.

Policy forms applicable to the policy may also be included. Often, these are combinations of letters and numbers—codings that refer to policy forms. To some, the **Declarations Page** is the most important

page of the document because it tailors the policy to you and your needs. This is where you'll find your name clearly written out with your address and the dollar amounts to things like your premium and deductible. The limits of coverages (both property and liability) are also detailed on this page, complete with values attached to them.

When you first receive your policy, the Declarations Page is where you'll want to go to find the details of your insurance and what's included in your coverage. Note the deductible and premium, as well as the limits of liability **per occurrence** and whether you've elected replacement cost or actual cash value. In some policies, electing cash value shows up as **full value on personal property** under Options.

PERSONAL PROPERTY

As we've seen, personal property includes everything that is not real property, such as indoor and outdoor furniture, linens, drapes, clothing, most appliances and all other kinds of household goods and equipment used for the maintenance of the dwelling.

Your personal property is covered under a renters policy while it is **anywhere in the world**. When personal property is located at an insured's residence, other than the residence premises, coverage is limited to 10 percent of the limit. This would be the case if you have a child away at college who is still under your care. Your child's property would be covered up to this limit. Personal property in a newly acquired principal residence is not subject to this limitation for the 30 days immediately after you begin to move your property there.

> At your request, your policy can cover property owned by others while the property is on that part of the residence premises occupied exclusively by any insured; and property owned by a guest or a residence employee, while the property is at any residence occupied by any insured.

In Chapter 1 we listed the 17 named perils covered by a renters policy. If your property is lost or damaged as a result of one of these perils, your insurance company will compensate you for your loss. There are some exclusions within these covered perils, however. Among them:

- Windstorm or hail does not include loss to the property contained in a building caused by rain, snow, sleet, sand or dust unless the **direct force of wind or hail** damages the building causing an opening in a roof or wall and the rain, snow, sleet, sand or dust enters through this opening.

- Aircrafts include self-propelled missiles and spacecraft.

- Smoke does not include loss caused by smoke from agricultural smudging or industrial operations, such as slash burns.

- Falling objects does not include loss to property contained in a building unless the roof or an outside wall of the building is first damaged by a falling object. Damage to the falling object itself is not included.

- Collapse of a building does not include settling, cracking, shrinking, bulging or expansion.

- Breaking of glass means damage to personal property caused by breakage of glass that is a part of a building on the residence premises. There is no coverage if breakage of glass is caused by an earthquake, and there is no coverage for loss or damage to the glass.

These are just a few of the specifics outlined in the covered losses section of a policy. Read this section carefully. Because freezing, for example, is a named peril covered by a basic policy doesn't mean that every case of freezing gets covered. There are limitations to be aware of.

Be careful of indirect losses that aren't covered. For example, many policies won't cover the damage done to your property from the sudden tearing apart of a hot water heating system if the sudden tearing was caused by pipes freezing.

PROPERTY NOT COVERED

Among the perils excluded from coverage are:

➡ **Earth movement**: sinking, rising, shifting, expanding or contracting of earth, all whether combined with water or not. This includes earthquake, landslide, mudflow, mudslide, sinkhole, subsidence, ero-

sion or movement resulting from improper compaction, site selection or any other external forces. Earth movement also includes volcanic explosion or lava flow.

➡ **Water damage**: flood, surface water, waves, tidal water, tsunami, overflow of a body of water, or spray from any of these, whether or not drive by wind; water below the surface of the ground, including water that exerts pressure on, or seeps or leaks through a building, sidewalk, driveway, foundation, swimming pool, hot tub or spa, including their filtration and circulation systems, or other structure; water that backs up through sewers or drains originating outside of the residence premises' plumbing system; or water that backs up, overflows or discharges, for any reason, from within a sump pump, sump pump well or any other system designed to remove subsurface water that is drained from the foundation area.

➡ **Power interruption**: means the failure of power or other utility service if the failure takes place off the residence premises. If any personal property losses usually covered ensues on the residence premises, the policy will pay only for the ensuing loss.

➡ **Neglect**: means failure to use all reasonable means to save and preserve property at and after the time of a loss, or when property is endangered.

➡ **War**: loss caused directly or indirectly by war, including the following and any consequence of any of the following:

• undeclared war, civil war, insurrection, rebellion or revolution;

• warlike act by a military force or military personnel; or

• destruction or seizure or use for a military purpose.

(Discharge of a nuclear weapon is considered a warlike act even if accidental.)

➡ **Nuclear hazard**: nuclear reaction, nuclear radiation or radioactive contamination, all whether controlled or uncontrolled, and whether or not one of the forces initiating or contributing to these nuclear hazards is covered within the covered losses except direct loss by fire resulting from the nuclear hazard is covered

➡ **Intentional loss**: any loss arising out of any act committed by or at the direction of an insured; and with the intent to cause a loss.

➡ **Acts or decisions**: including failure to act or decide, of any person, group, organization or government body. But any ensuing loss not excluded is covered.

➡ **Weather that contributes** in any way with a cause or event normally excluded to produce a loss. But any ensuing loss not excluded is covered.

➡ **Planning, construction or maintenance**: faulty, inadequate or defective planning, zoning, development, surveying, siting; design, specifications, workmanship, repair, construction, renovation, remodeling, grading, compaction; materials used in repair, construction, renovation or remodeling; or maintenance of property whether on or off the insured location by any person or organization.

LOSS OF USE

If you suffer a loss covered by your policy, which makes the part of your residence premises where you reside uninhabitable, the policy will cover **additional living expenses**. This means any necessary increase in living expenses you incur so that your household can maintain its normal standard of living. Most policies set a limit as to the duration of this coverage. For example, *Payment shall be for the shortest time required to repair or replace the damage or, if you permanently relocate, the shortest time required for your household to settle elsewhere, but not to exceed 12 months.*

Depending on an individual policy's language, if the covered loss affects either that part of your apartment or house where you reside or rent out to others or hold for rental, then a policy will typically cover fair rental value. **Fair rental value** means the fair rental value of that part of the residence premises you rent to others or hold for rental, less any expenses that do not continue while the residence is uninhabitable.

Again, limits to this coverage vary but typically have 12 months maximums.

Loss of use also covers a situations where a civil authority prohibits you from using your residence premises as a result of direct damage to a neighboring premises by a covered loss. In this instance, your policy will cover the additional living expenses or the fair rental value for a certain time period. The time period for this kind of coverage is usually more limited, and may be as short as two weeks.

One last note about loss of use coverage: No deductible applies.

ADDITIONAL PROPERTY COVERAGES

This section of the policy will outline additional coverages not already mentioned. Some of these include:

- debris removal;
- trees, shrubs and other plants;
- reasonable repairs;
- fire department service charge;
- property removed;
- building additions and alterations;
- arson reward; and
- locks.

There are certain conditions and limitations to these additional coverages, so check your policy carefully.

Coverage for building additions and alterations, for example, means building additions, deletions, alterations, fixtures, improvements or installations made or acquired at your expense and used in that part of the residence premises used exclusively by you. The limit of liability for this coverage typically does not exceed 10 percent of the limit of liability that applies to your other coverages.

See Chapter 5 for more information regarding the definitions of these terms.

PROPERTY CONDITIONS

Following Section I of your renters policy, which outlines the property coverages, you'll find Section II—Property Conditions. This is where certain conditions are described with regard to the coverages outlined above. The following is a brief look at some of these:

Deductible. Your policy will cover only that part of the loss over the applicable deductible stated in the Declarations. Deductibles often don't apply to Loss of Use (Coverage D) or Fire Department Service Charges.

Your Duties to Select and Maintain Policy Limits. You need to ensure that you've acquired adequate coverage for your personal property. Due to fluctuating economic conditions, your insurance company may change your policy's limits on an annual or *pro rata* basis.

An Insured's Duties After Loss. You are required to do certain things when faced with a loss. These include:

- Cooperating with the insurance company in any investigation, settlement or defense of any claim or suit;

- Giving immediate notice to your insurance company of any loss—including the police in case of loss by theft;

- Protecting property from further damage, making reasonable and necessary repairs to protect the property and keeping good records; and

- Preparing an inventory of the loss (showing in detail the quantity, description, actual cash value and age using bills, receipts and related documents).

Insurable Interest and Limit of Liability. The insurance company will not be liable for any one loss to you for more than the amount of your interest at the time of the loss or for more than the applicable limit of liability, whichever is less.

Loss Settlement. Covered property losses are settled at the time of the loss but will not exceed the smallest of either the applicable limit of liability, the direct financial loss or the company's pro rata share of any loss when divided with any other valid and collectible insurance applying to the covered property at the time of the loss.

Loss to a Pair or Set. The insurance company may elect to repair or replace any part to restore the pair or set to its value before the loss or pay the difference be-

tween the actual cash value of the pair or set before and after the loss.

Appraisal. If you and your insurance company cannot come to agreement over the value of your loss, then both you and your insurance company must choose a competent and disinterested appraiser, notifying the other of the appraiser selected within a specific amount of time. Then, the appraisers agree on an umpire; each party pays its own appraiser and bears the other expenses of the appraisal and umpire equally.

Suit Against the Insurance Company. You cannot start any suit against your insurance company outside of the policy provisions or after one year from the date of the loss.

Insurance Company's Option. If your insurance company gives you written notice within 30 days after it receives your signed, sworn proof of loss, it may repair or replace any part of the property damaged with equivalent property.

Loss Payment. Your insurance company will adjust all losses with you, paying you unless some other name exists in the policy. You can expect to receive payment 30 days after you and your insurance company reach an agreement, there is an entry of a final judgment or there is a filing of an appraisal award with the insurance company.

Abandonment of Property. The insurance company will not accept any abandoned property.

No Benefit to Bailee. You cannot assign or grant any coverage for the benefit of any person or organiza-

tion holding, storing or transporting property for a fee regardless of any other provision in the policy.

Other Insurance. If a loss is also covered by other insurance, your policy will pay only the proportion of the loss that the limit of liability that applies under the policy bears to the total amount of insurance covering the loss.

Recovered Property. If you or your insurance company recovers property for which you've already received payment under the policy, your insurance company will adjust the loss payment.

Salvage Value. Any value that may be realized from salvage will not diminish the amount owed by you under the deductible clause.

In Chapter 4 we'll go into the mechanics of liability, which takes up the second part (Section II) of a renters policy. Similar to the first section that deals with property coverages and condition, Section II outlines the liability coverages and conditions.

Following these two detailed sections is another that goes over more conditions to the policy as a whole. Some of these detailed conditions include

- policy period and changes;
- concealment or fraud;
- liberalization clause;
- cancellation;
- non-renewal;
- assignment;

- an insurance company's right to recover payment; and

- death.

All of these conditions are important to you as a policyholder. Cancellation is a big topic, for example, for those who aren't responsible about paying premiums on time. An insurance company has the right to cancel any policy at any time so long as it notifies you in advance. If you forget to pay your premium and you don't pay attention to cancellation notices coming to you in the mail, you won't be able to make any claims to lost property when something happens.

If you cannot afford to pay an annual premium up front in one payment, some insurance companies can make paying monthly premiums on time easier by setting up a checkless payment plan with you. You simply give them a voided check that allows them to access your checking account once a month to deduct for the money owed on the premium.

Every policy has different provisions for cancellation and renewing. Check the specifics of your policy to ensure that you understand these important clauses. You don't want to learn after the fact that your policy had already been voided by something you did (or didn't do).

CONCLUSION

This chapter has shown you some of the basic mechanics to a renters policy—particularly the property

coverages portion. Before we take a closer look at the liability portion of a policy, which makes up the second part to a policy, we are going to show you how to calculate **how much you are worth**. For most people, this has more to do with the value of your personal property than anything else. Then, in Chapter 4 we'll explain why liability is such a major issue...and how it can affect how you decide to price your possessions.

CHAPTER

3

HOW MUCH ARE
YOU WORTH?

Before you can shop around for renters insurance, you need to have an idea of how much coverage you need. In other words, how much are you worth? That's a pretty broad question. Of course, *you* are worth more than your possessions, but when it comes to renters (and homeowners) policies, it's more about your possessions than you.

Net worth is typically **assets minus liabilities**. Young renters don't usually have a high net worth. We stated in the first chapter that the average new renter right out of college has accumulated roughly $30 thousand worth of things that a renters policy would help cover in the event of a total loss. These things—stereo, computer, DVD, clothes, jewelry—are assets. But, despite what you might think, young people are not free of liabilities.

If you have credit card debt, car payments or student loans to pay off, you carry liabilities. In fact, you might carry more liabilities than assets, but it's nice to know that a policy can cover the assets that you do have.

> Once you've calculated the value of the things you own, you simply have to ask yourself: How much of this could I stand to lose?

Your answer to this question will determine whether or not you opt for a policy and what kind. If you're a rich renter who hates homeownership but owns a ton of valuable items, then a renters policy is a must-have.

PERSONAL ASSET INVENTORY

Start with a list of your possessions. This may seem like a hassle, but it'll also provide you with a mental idea of what you actually own. You may also want to **take photographs**, use a video camera or use an audio tape to accompany your list.

> Having visuals of your possessions in the form of photographs or videos is a good idea. When you have to file a claim for, let's say, a rosewood desk burned by a fire, turning in a photograph of the desk pre-fire to the insurance company won't hurt your claim. In fact, it will help prove your losses. For items that have serial numbers, write them down or say aloud what they are into a recording device. Include receipts, purchase contracts or appraisals if you have them, as well as dates of purchase and how much you paid for them.

The best way to go about this daunting task is to divide the list up room by room. Start in an easy room, like the living room, and begin with the most recently-purchased items. The following is a general checklist of things to consider.

A General Checklist

- all furniture, pictures and wall hangings
- books, clocks, bookshelves or shelving units
- entertainment center
- lamps/light fixtures
- television, VCR, camcorder, DVD, stereo, CD player
- radios, record player, records/CDs/tapes
- piano, musical instruments
- mirrors, vases, plants/planters, fireplace equipment
- coin collection, stamp collection
- portable AC
- area rugs/tapestries, curtains, drapes
- china, silverware, crystal, tablecloths and napkins
- tea or coffee set
- headboards, mattresses, box springs, sewing machine
- firearms
- computer, printer, scanner, camera, fax machine
- answering machine, phone/cordless phone
- tape recorder
- wardrobe, clothes hamper
- electrical appliances, scale
- shower curtain, linens, toiletries/bathroom articles
- refrigerator, freezer, microwave, food processor
- small appliances, pots/pans, dishes, silverware
- cooking utensils/tools, glasses, step stool
- cleaning tools, food/supplies, liquor, wine
- luggage, trunks, sports equipment, toys/games
- space heater, dehumidifier, gardening items
- pet supplies, canned food, holiday decorations/crafts
- outdoor cooking equipment.

For clothing, count the items by category—pants, coats, shoes, shirts, etc. Make notes about items of clothing

that are especially valuable. Remember that major appliances and electronic equipment usually have serial numbers on them.

DOLLAR LIMITS TO SOME ITEMS

The following items are subject to special limits shown on your policy. You may be able to add to the specified limits through a rider or endorsement. The values here are typical of a generic policy (note: this list is not inclusive):

- $250 on money, pre-paid cards or passes, monetary value on an electronic chip or magnetic card, bank notes, bullion, gold other than goldware, silver other than silverware and platinum.

- $3,000 on rare coins and currency, medals, stamps, trading cards and comic books.

- $1,500 on securities, debit cards, checks, cashier's checks, traveler's checks, money orders and other negotiable instruments, accounts, deeds, evidences of debt, letter of credit, notes other than bank notes, manuscripts, passports, tickets, personal documents, and records or data.

- $1,500 on watercraft, including their trailers, furnishings, equipment and outboard motors.

- $1,500 on trailers not used with watercraft.

- $1,500 on any one article, but not more than $3,000 in the aggregate for loss by theft of jewelry, watches, furs, precious and semiprecious stones.

- $3,000 for loss by theft of silverware, silver-plated ware, goldware, gold-plated ware and pewterware.

- $5,000 on business property while located on the premises.

- $1,000 on business property while located away from the premises.

- $200 on tapes, records, discs or other media in a motor vehicle on or away from premises.

- $5,000 on any one article, but not more than $10,000 total, for loss by theft of any rug, carpet (except wall-to-wall carpet) tapestry, wall-hanging or similar article.

- $2,000 on grave markers.

Firearms also have limits in the event they are stolen. If you're a gun collector, ask about additional insurance. If you have doubts about anything you own, ask an insurance agent. Everyone's insurance needs are so different that no two inventories are the same, and **no two policies are equal**. Often policies are purchased without an agent going through the dwelling to help inventory. Don't assume, for example, that your premier wine cellar will be covered by a basic policy. Always ask about specific coverage.

> Making an inventory list is hard. Go room by room. Try to pick out the items for which you'll want special coverage. For example: a mink coat; a diamond ring; or a $10,000 computer set-up. Most policies don't cover computers over $3,000, so if you've got a high-tech home office, consider a special endorsement to your policy.

Make copies of your inventory list and keep one in a safe place that won't be consumed by a disaster that strikes your abode. Think about keeping a copy at work, a friend's house or in a safe deposit box.

Other tips for arriving at the magic number:

1) Use a table or spreadsheet. Some personal finance software packages include a room-by-room inventory program.

2) Ask an agent to help you determine your net worth. Insurance agents have systems available to help you determine the approximate cost of replacing your possessions based on the size or number of rooms in your dwelling.

3) Don't overlook things that may have *increased* in value, such as jewelry, art work and collectibles. Check to make sure you've got adequate insurance for these things.

4) Don't forget about the items in drawers, storage closets and even under the bed.

PROPERTY NOT COVERED

There are some things that a broad theft coverage renters policy will *not* cover no matter how much they mean to you. These items will be listed under "Personal Property We Do Not Cover" and typically they include:

- aircraft and parts, other than model or hobby aircraft;

- animals, birds or fish;

- business property of an insured person or residence employee on or away from the described location;

- credit cards and fund transfer cards;

- motor vehicles, other than motorized equipment which is not subject to motor vehicle registration and which is used to service the described location, or is designed to assist the handicapped;

- motor vehicle equipment and accessories, and any device for the transmitting, recording, receiving or reproduction of sound or pictures which is operated by power from the electrical system of a motorized vehicle, including tapes, wires, discs or other media for use with such device, while in or upon the vehicle;

- property held as a sample or for sale or delivery after sale;

- property of tenants, roomers and boarders not related to an insured person;

- property separately described and specifically insured by any other insurance;

- property while at any other location owned, rented to or occupied by any insured person, except while an insured person is temporarily residing there;

- property while in the custody of any laundry, cleaner, tailor, presser or dyer except for loss by burglary or robbery;

- property while in the mail.

You may recognize some of these exclusions from standard homeowners and dwelling policies.

The broad theft form usually adds **two conditions** that can influence whether or not property (which would otherwise be covered) is covered:

1) Theft coverage requires the insured person to notify the police of a theft.

2) If theft is also covered by another type of insurance, the insurance company is only obligated to pay the proportion of the loss that the limit of liability under the theft endorsement bears to the total amount of insurance.

So, when you're taking inventory of your possessions, don't worry about including your goldfish or the camcorder you're borrowing from a friend for an indefinite amount of time. And if you really feel the need to get coverage for these items, ask an insurance agent if there's any way to obtain special coverage for them. Later in this chapter we'll go over personal property floaters and other such endorsements to your standard policy.

BEWARE OF MORE EXCLUSIONS

Other situations may affect your coverage under a renters policy. Although we'll go into greater detail about the use of your rented dwelling for business purposes (in Chapter 9), it's worth noting them here, as well as a few other important things to consider:

➥ Property used for business purposes isn't considered personal property and, therefore, isn't covered.

➥ Only property that belongs to an insured person is covered. So, if the $4,000 tandem bike you're storing for a friend in the garage is stolen, you may be liable.

➥ Property of residence employees is covered only if you ask the insurance company to add specific language. This may raise problems—though many companies will add the coverage for no additional cost.

The following two pages contain charts that will help you organize your inventory and divide your list into relevant room. Use this as a guide for evaluating your insurable possessions.

Household Property Inventory

	Foyer or entry area		Living room		Dining room		Kitchen		Bedroom #1 (including closets)		Bedroom #2		Other bedrooms	
	Property	Value	Property	Value	Property	Value	Property	Value	Property	Value	Property	Value	Property	Value
Furniture														
Appliances														
Clothes														
Other														

	Bathroom #1		Bathroom #2		Other bathrooms		Den or home office		Basement		Porch or patio		Garage	
	Property	Value	Property	Value	Property	Value	Property	Value	Property	Value	Property	Value	Property	Value
Furniture														
Appliances														
Clothes														
Other														

LIABILITY COVERAGE

Besides your possessions, renters insurance is about liability. Liability is a big deal in today's world, which is why the entire next chapter is devoted to it. Part of your worth factors into liability, or how much you are **legally responsible for occurrences at home**. Anyone can sue you—an angry neighbor, the UPS guy who slipped on your front porch, the parents of a kid in your daughter's Girl Scout troop. If the person suing you wins a judgment in court, you either have to reach a cash settlement or face the court seizing any assets you have—including your future income.

Most renters policies pay up to $100,000 each time someone makes a legitimate liability claim against you. If the liability claim against you is more than $100,000, you would have to pay the difference.

The issue of how much liability coverage you need has a lot to do with your financial condition. The claims against you don't even have to hold up in court to hurt you financially. The cost of hiring an attorney to defend you in a civil lawsuit can easily reach $10,000. This is another reason liability insurance is valuable— it covers the costs of **mounting your legal defense**. It's a little easier to gauge how much you need to protect yourself from liability when you're a renter. People who own homes, for example, worry about being insured against their non-mortgaged equity or the total assessed value. Those people who have a house worth several hundreds thousand dollars have a large enough investment there—and probably else-

where, too—that they need as much coverage as they can buy at a reasonable price.

Renters, on the other hand, don't have equity in their dwellings. When you rent, you don't have to worry about a court putting a lien against any equity. So you have to think about what a court could take away from you to help pay for damages should you be held liable. Among the things to consider when you calculate your insurable net worth:

- major personal assets (jewelry, collectibles, etc.);

- savings or liquid investments;

- pension funds (IRAs, Keough or other group accounts like a 401(k), ESOP or traditional pension plan;

- automobiles; and

- income.

Pension benefits aren't usually exposed to legal judgments. But they have been called into question, occasionally, when calculating damages levied against someone. For this reason, you should probably include pension benefits when calculating your insurable net worth.

If you find that you are worth a great deal more than what you renters policy can provide for the price, you may want to consider an **umbrella liability policy**. This pays up to a predetermined limit (usually $1 million) for liability claims made against you or your family. (See Chapter 8 for more information about this kind of insurance.)

PERSONAL ASSETS INVENTORY

	market value	related debt and restrictions	net value
1. home	_____	_____	_____
2. other real estate	_____	_____	_____
3. capital investments	_____	_____	_____
4. cash savings	_____	_____	_____
5. accessible pension accounts	_____	_____	_____
6. cars, other vehicles	_____	_____	_____
7. art, other collectibles	_____	_____	_____
8. jewelry, etc.	_____	_____	_____
9. recreational equipment	_____	_____	_____
10. other items	_____	_____	_____
total	_____	_____	_____

List most recent comparable value or insured value from other coverages for market value.

Debts and restrictions include mortgages, liens and other encumbrances on real estate. They would also include margin loans on capital investments and liquidation costs or penalties on accessible pension funds.

Art, jewelry and other collectibles may be covered separately. If so, you may choose to keep them out of this calculation.

The previous page contains a **Personal Asset Inventory** chart. The total value of these things—even if you couldn't raise it all by selling everything tomorrow—is what you need to protect.

Currently, personal liability coverage on a renters policy is at $100,000 and medical payments to other is covered at $1,000 per person. We'll go into detail about what this means in the next chapter. We'll also explain the limits of liability common to renters policies, which can change what kind of insurance you obtain.

THE COLLEGE STUDENT

As we've already mentioned, you cannot underestimate the value of your personal possessions (and liability) even if you still rely on your parents for many things—including insurance coverage. And if you are a parent with a child in college, don't assume that your family policies will cover any mishaps that occur to your son or daughter at school. **Theft is the number one crime** on college campuses, and more than 80 percent of students who rent apartments have no insurance to protect their personal property. Think about these stats, provided by the Independent Insurance Agents of America (IIAA):

- 8.9 million U.S. households have full-time college students under age 23, and over half of all undergraduates live away from home during the school year;

- Nearly one in five rents an apartment;

- More than 100,000 property crimes on college campuses are reported to police each year; and

- Thieves take an average of $1,250 worth of student property per theft.

There's a lot that can happen to Jane and Dick while they're enjoying the comforts of college life. The IIAA points out that an uninsured loss, such as the theft of a laptop or a liability claim stemming from a party mishap, can deal a devastating blow to a college student's limited bank account or the financial status of a parent already struggling with high tuition bills.

Parents and their student children don't think much about renters insurance, but they should. A typical homeowners policy covers property away from home up to a limit of 10 percent of the contents coverage.

For example: If your homeowners policy insures your home for $100,000, the contents are covered for half of that amount, or $50,000. Property away from the home is covered for $5,000 minus the policy's deductible. This means that if your son suddenly loses property equal to $4,500 (e.g., laptop, digital camera and scanner) and your deductible is $3,800, your homeowners policy won't be much help. And, if your son lives off campus, your policy may not even be of any help.

First thing to do is **check with your current policy** to see how much it would help a student in college if something were to happen. In most cases, it's best to simply buy a policy for a college student because chances are, he or she will have more complete coverage under a separate policy than he or she would have under a typical homeowners policy. Off-pre-

mises coverage is always limited. Don't forget to take into consideration valuable items that may need more coverage than what a general homeowners or renters policy would provide.

> If you've equipped your son or daughter with an expensive computer to take to college, or if he or she has any other valuable items (i.e., jewelry, bicycle, stereo, etc.), it's a good idea to add a personal articles floater to your existing homeowners policy or purchase a separate renters policy for your child. Either way, check with the policy's specific exclusions and coverage limits.

The following is a checklist of safety measures your child can practice when he or she is away at school:

- ☐ Lock the doors and windows, and close curtains;

- ☐ Engrave expensive possessions with an ID such as a driver's license, serial number or name;

- ☐ Keep an inventory of expensive items, along with original receipts and photos;

- ☐ Leave the most expensive items at home;

- ☐ Never leave backpacks or computer cases unattended (think about traveling with a laptop in a backpack instead of a computer case);

- ☐ Don't have valuables on display; and

☐ Report any suspicious incidents to the police or campus security.

When buying a policy for a college student, make sure you choose coverage for the replacement cost of property and not fair market value. This will allow the student to fully replace any and all stolen property.

Students most at risk for property loss include those who:

- live away from home;

- rent (especially those who rent in their own name or co-sign a lease with a parent);

- live in group houses (e.g., sororities or fraternities, off-campus housing);

- live in large cities or high-crime areas;

- travel frequently;

- run businesses from their dorm or apartment;

- host frequent parties; and

- have animals (especially dogs) at school.

A good source if information about crime on college campuses can be found on the FBI's Web site at *www.fbi.org*. A 1995 report called Crime in the United States lists the number of property crimes on college campuses reported to police by school. Alternatively, the organization College Parents in America can provide useful information. You can contact this organization at (800) 256-4627 or on the Web at *www.collegeparents.org*.

ODDBALL ITEMS COVERED

There are some items that a renters policy will cover that are not necessarily at home when the loss occurs. They may include:

- an item normally kept at home, such as a bicycle or camera, that gets stolen elsewhere, such as from your car or out of your backpack in Europe;

- golf carts;

- motorized land vehicles not subject to motor vehicle registration or licensed for road use and used solely to service the residence premises;

- devices used for transmitting, recording, receiving or reproducing sound or pictures, so long as the devices are not permanently installed in a motorized land vehicle;

- vehicles designed for the handicapped (and not licensed for road use); and

- disassembled parts of a motorized land vehicle (e.g., a radiator, the dash to your Cobra).

We mentioned above that you might find it hard to recover anything from the loss of an item that didn't belong to you but that you were keeping in your apartment for a friend or family member. Basic policies, however, will oftentimes have a clause, which states:

At your request we cover:

a) personal property owned by others while the property is on that part of the **resi-**

> **dence premises** occupied exclusively by any **insured**; and

b) personal property owned by a guest or a **residence employee**, while the property is at any residence occupied by any **insured**.

Remember: Renters insurance is a package of several types of insurance designed to cover you for more than one risk. Each policy is slightly different— types of coverage offered, exclusions, the dollar amounts specified and the deductible will vary. Shop around to find the type of coverage you need.

PROPERTY FLOATERS

If you own valuable personal property that is often moved around, you may need a broader and more comprehensive coverage than the coverage provided by your renters policy.

Floaters provide an **extended coverage** with respect to the perils that are covered under a policy. They are generally written to cover direct physical loss to a described property except for various exclusions.

A typical renters policy limits coverage for specific kinds of property, as we saw earlier in this chapter. And for some of these items (e.g., jewelry, firearms, silverware), coverage is further limited to theft-only.

A **personal property floater** (PPF), covers personal property owned or used by you that is normally kept

at your home. The PPF also offers worldwide coverage on the same property when it is temporarily away from your home and it is insured on an **all-risks** basis—meaning that all direct losses will be covered unless they are specifically excluded.

The PPF insures the following unscheduled property:

- silverware, goldware, and pewterware;
- clothing;
- rugs and draperies;
- musical instruments and electronic equipment;
- paintings and other art objects;
- china and glassware;
- cameras and photographic equipment;
- guns and sports equipment;
- major appliances;
- bedding and linens;
- furniture;
- all other personal property, and professional books and equipment while in your home; and
- building additions and alterations.

The amount of insurance available in each class is the maximum limit of recovery for any one loss in that category. Adding these up will give you the **total policy limit**. Check with your insurer on the total limits available.

UNSCHEDULED PROPERTY

Unscheduled personal property typically requires a $100 deductible for each separate loss, but, if you want to reduce your premium, a higher deductible is also available.

An unendorsed homeowners policy will cover your unscheduled personal property on a named perils basis. But, you may own some valuable personal property which would be better covered if it were scheduled and specifically insured under a floater policy. **High-valued** property such as jewelry, fur coats, etc. generally fall into this category. If you own any of the following items, you may want to consider purchasing a floater policy:

- **unique objects**, including works of art, antiques, paintings and collections of unusual property (such as a valuable stamp or coin collection);

- **portable property**, including cameras and camera equipment, musical instruments or sports equipment;

- **fragile articles**, with a high value such as glassware, scientific instruments or computers;

- **business or professional equipment**, which your homeowners policy will only insure for a maximum of $2,500 at your home and $250 away from your home, can be insured more adequately by scheduling the property with a stated amount of insurance.

> Be sure to establish the value of all property in advance—by doing this, you will avoid having to prove its value after a loss occurs.

EXCLUSIONS

The following types of property are not covered under a personal property floater:

- animals, fish and birds;

- boats, aircraft, trailers and campers;

- motor vehicles designed for transportation or recreational use;

- equipment and furnishings for the above vehicles unless removed from the vehicle and located at your place of residence;

- owned property of a business, profession or occupation (except books, instruments and equipment which is covered while in your home); and

- property usually kept somewhere other than your place of residence throughout the year.

In addition to the property not covered under a personal property floater, a floater also has specific losses which are excluded from coverage. These include losses caused by:

- animals owned or kept by you;

- insects or vermin;

- marring or scratching of property, break-age of glass or other fragile articles (except if caused by fire, lightning, theft, vandalism or malicious mischief and certain other perils);

- mechanical or structural breakdown (except by fire);

- wear and tear, deterioration or inherent vice;

- dampness or extreme changes of temperature (except if caused by rain, snow, sleet, hailing or bursting of pipes or other apparatus);

- any work on covered property (other than jewelry, watches and furs);

- acts or decisions of any person, group, organization or governmental body; and

- water damage.

If you're planning to get divorced, you may want to obtain your own floater policy because chances are, you won't find coverage at the expense of your ex's insurer.

PERSONAL EFFECTS FLOATER

If you are planning on taking a trip, you may want to consider a **personal effects floater** (PEF), designed for people who want to cover their personal possessions while traveling.

A PEF provides "all-risk" coverage for your property anywhere in the world— but only while the covered property is away from the residence premises and only for you, your spouse and any unmarried children who live with you.

Personal effects refers to any personal property that you would normally wear or carry. It is designed to cover items such as luggage, clothes, cameras and sports equipment, while you are traveling or on vacation.

A PEF excludes coverage for:

- automobiles, motorcycles, bicycles, boats and other conveyances and their accessories;

- accounts, bills, currency, deeds, evidence of debt and letters or credit;

- passports, documents, money, notes, securities and transportation or other tickets;

- household furniture and animals;

- automobile equipment, sales peoples' samples, and physicians' and surgeons' equipment;

- contact lenses and artificial teeth or limbs; and

- merchandise for sale or exhibition, theatrical property and property specifically insured.

Property covered under a personal effects floater must be used or worn by you and it must also belong to you. If you borrow property from anyone else other than another insured, you will not be covered for its loss.

Under the PEF, your personal effects are covered on an "all-risks" basis except for:

- damage to your personal effects as a result of normal wear and tear, gradual deterioration, insects, vermin, inherent vice or any damage while the effects are being repaired;

- breakage of brittle articles unless a result of theft, fire or accident to a conveyance;

- damage to effects while at your place of residence;

- damage to effects while property is in storage. (However, if you store your luggage in a locker at the airport or train station while traveling or vacationing, the exclusion does not apply.);

- any damage to effects while in the custody of a student at school—except for loss by fire.

Personal effects are also subject to limitations.

Coverage for any single piece of jewelry, watches or furs is limited to 10 percent of the total amount of insurance with a maximum of $100.

You won't find coverage for theft of personal effects from an unattended automobile under a personal effects floater. However, coverage would apply if the automobile was locked and there were visible marks of forcible entry. The amount paid would be limited to a maximum of 10 percent of the total amount of insurance or $250, whichever is lower.

INDIVIDUAL ARTICLES FLOATER

In addition to the personal effects floater, a number of **individual articles floaters** can insure specific types of personal property for scheduled amounts. Usually issued as inland marine forms, separate floaters are available to insure bicycles, cameras, fine art, golfer's equipment, jewelry and furs, musical instruments, stamp and coin collections, silverware and more.

When you are taking the time to insure your personal property for scheduled amounts, be sure to know the exact value of your property. This may cost you time and money—but it will save you a bundle of money in a the event of a lawsuit. Take a look at this case, in which parties argued the correct appraised value of property.

Francis Maxwell, a Dean of Educational Administration at Belleville Area College in Illinois and collector of art objects, purchased 14 separate oriental art objects from Charles Bueche for $19,800. Bueche also furnished Maxwell with an appraisal of the 14 pieces of art in which he stated their value to be $275,800.

About a month later, Maxwell made a request for coverage of fine art works through a local broker, but, he failed to advise Lloyd's that the dealer who had appraised the works of art at a value of $275,800, was the same dealer who sold him the art for only $19,800. Lloyd's issued Maxwell a cover note of insurance on the objects in the amount of the appraisal.

On or about March 6 of the next year, all of the items were stolen from Maxwell's apartment and he notified Lloyd's of his loss.

In an investigation, Lloyd's discovered the great discrepancy between what Maxwell paid for the works of art and their appraised value. They also learned that the seller of the art objects had also furnished the appraisals and had declined payment, but offered to refund the premium Maxwell had paid.

Maxwell filed suit and sought to recover $245,800 for the stolen items. At the trial, Lloyd's presented evidence which showed that the art items were not of the nature and value Maxwell had represented them to be. Bueche's valuations were also brought into question by investigating his initial acquisition of the pieces of art.

The court ruled that the value of the items did not remotely resemble items of the value of $275,800 and that had the transaction between Maxwell and Bueche been submitted, coverage would not have been issued.

However, the court found that Maxwell was under no duty to report the source and purchase price of the art objects because Lloyd's did not ask him to and

therefore, did not enter into a planned scheme to defraud Lloyd's. Furthermore, they concluded that only the most naive, or the most blissfully ignorant person, could believe that they could purchase genuine objects of art valued at $275,800 from an established art dealer and appraiser for less than one-thirteenth of their value.

> You can purchase an individual floater when you need to insure personal property that is concentrated in one or two classes of property. When there is a need to insure multiple classes of property, it is more practical to use a personal articles floater.

PERSONAL ARTICLES FLOATER

The **personal articles floater** (PAF) is a basic form used to insure certain classes of personal property on an itemized and scheduled basis. It is almost identical to the scheduled personal property endorsement which may be attached to a homeowners policy.

The PAF usually contains a pre-printed schedule that lists the following classes of insurable property:

- jewelry;
- furs;
- cameras;
- musical instruments;
- silverware;
- golf equipment;

- fine art;

- stamps; and

- coins (coins include paper money and bank notes owned by or in the custody or control of the insured).

For each class of property covered, an amount of insurance must be shown and the article(s) must be described.

Other classes of property may be included in the PAF, but they are generally subject to the appropriate rates and forms. Depending upon your insurer, the pre-printed schedule may include lines referring to boats and other items.

You may want to purchase a scheduled personal property floater to provide coverage that is similar to the personal articles floater for valuable items that don't fall within the above categories.

Scheduled personal property floaters can be purchased to cover almost any type of property, including dentures, typewriters, camping equipment, wheelchairs, stereo equipment, grandfather clocks, etc. To obtain this type of coverage, speak to your agent about the unfiled forms which can be adapted to meet your needs.

NEWLY ACQUIRED PROPERTY

If you have newly acquired property, check your PAF, you may find automatic coverage. For coverage to

apply, an amount of insurance must already be scheduled for the property class. And you must report the acquisition of property to your insurance company. If you don't report it, there may be no coverage.

If you acquire any new jewelry, furs, cameras or musical instruments, the personal articles floater will cover you for the actual cash value of your property up to $10,000 or 25 percent of the amount of insurance already scheduled—whichever is less.

If you bought a mink coat, you have 30 days from the date of purchase to report the purchase to your insurer, in order for coverage to apply.

Your PAF also will only cover you for the actual cash value up to 25 percent of the amount of insurance already scheduled for newly acquired fine art. However, make sure that you report the item to your insurance company within 90 days.

If fine art is insured, the coverage applies only within the United States and Canada.

WHAT'S COVERED?

The personal articles floater will insure your property against all risks of direct physical loss except losses caused by war, nuclear hazards, wear and tear, deterioration, inherent vice and insects or vermin.

Additional exclusions apply to specific classes of property. For example, loss or damage to immobile

musical instruments won't be covered if caused by repairing, adjusting, servicing or maintenance operations, or any mechanical or electrical failure. However, any following damage by fire or explosion is covered.

If your Renoir painting is insured, the coverage won't apply to damage that is caused by repairing, restoration or retouching, and if you display your Renoir at an art exhibit at the local fairgrounds, any losses to the property will not be covered unless the exhibition premises are covered by your policy.

> If a loss to a fine art pair or set occurs, a PAF will pay you the full scheduled amount for the set only if you surrender the remaining articles of the set.

All scheduled property other than fine art is covered on an actual-cash-value basis. But the policy won't pay more than the stated amount of insurance, or the amount for which you could be expected to repair or replace the property. If you experience a loss to a pair or a set for any property other than fine art, your insurance company has the option to repair or replace any part of the pair or set, or pay the difference between the actual cash value of the property before and after loss.

Breakage of glass objects of art, statuary marble, bric-a-brac, porcelain, and similar fragile items is covered only when caused by fire, lightning, explosions, aircraft, collision, windstorm, earthquake, flood, malicious damage, theft or derailment or overturn of a

conveyance. All-risk glass coverage may be purchased too.

Unscheduled stamps or coins that are covered on a blanket basis (multiple types of property at a single location or one or more types of property at multiple locations) are insured for their market value. However, coverage for any single stamp or coin is limited to $250 and coverage for any one coin collection is limited to $1,000.

Losses to your stamp or coin collections are not covered if caused by fading, creasing, denting, scratching, tearing, thinning, transfer of colors, inherent defect, dampness, extremes of temperature, depreciation, theft from an unattended automobile and damage from being handled or worked on.

Stamps and coins also aren't covered while they are in the custody of transportation companies or during the process of shipment by any form of non-registered mail. And they won't be covered for disappearance unless each item is described in the policy and scheduled with a specific amount of insurance.

All stamps or coins covered by a personal articles floater must be part of a collection.

There are a number of conditions that appear in a floater covering your personal property. The most important include:

Loss Settlement. With a few exceptions, the amount paid for a covered loss is the lowest of the following:

1) the actual cash value at the time of loss or damage;

2) the amount for which the insured could reasonably be expected to have property repaired to its condition before the loss;

3) the amount for which the insured could reasonably be expected to replace the property with property most identical to the item lost or damaged; or

4) the amount of insurance stated in the policy.

Loss to a Pair, Set or Parts. In the event of property damage or loss to a pair or set, such as the loss of one candelabra, the amount paid is not based on a total loss—the insurer may choose to:

1) repair or replace any part to restore the set to its value before loss; or

2) pay the difference between the actual cash value of the property before and after the loss.

Claim Against Others. Similar to the subrogation clause, if a loss occurs and your insurer believes that it can recover the loss payment from the person or parties responsible, a payment of loss to you would be considered a loan. This means that any recovery you would receive from others after you have received your loan would have to be paid to the insurance company.

Insurance Not to Benefit Others. This provision states that no other person or organization that has custody of the property and is paid for services can benefit from the property's insurance. A third party who was responsible for the loss would not be able to deny liability for payment because the property is insured. Thus, the insurance company's right of subrogation against the negligent party is retained.

Other Insurance. If you have any other insurance that applies to the property at the time of loss (not including this policy), the insurance would be considered excess over the other insurance.

OTHER FLOATERS

Some insurers offer a number of floaters to meet special needs. Here are just a few.

Wedding presents floater. This floater is a short-term (typically 90 days) policy which covers the wedding presents of the bride and groom while on their honeymoon. Permanent coverage is also available under a homeowners or renters policy, but in some situations there is a need for temporary coverage. However, breakage to fragile items is excluded, as well as several classes of property: vehicles, real estate, money, etc.

Trip transit floater. This is the personal property floater version of similar **commercial floaters**, sold by many travel agencies. Designed to cover one's personal property for just one trip (the one made, for instance, from the insured's old residence to a new one), a trip transit form usually covers loss from fire, flood and transportation perils. Coverage for other

perils, such as theft, can be purchased by endorsement.

Sports memorabilia. Growing in popularity, this floater is used to insure all sorts of sport-related items (not just trading cards). Many insurers don't have a filed policy to cover these, sometimes extensive, collections. The excess and surplus lines market directories contain listings of brokers who provide coverage on either a blanket or a scheduled basis, and can cover the items even while in transit or off premises. You may even want to check with the sports memorabilia store where you do most of your business. Usually, dealers know of brokers who handle such items.

Large coin and stamp collections. Although the scheduled personal property endorsement or a personal articles floater covers coins and stamps, it may not provide adequate coverage for the special needs of a large collector. In many cases, coverage is limited (mysterious disappearance is not covered), and the property may only get limited coverage while on exhibition. (Coin and stamp collectors often take their collections to exhibitions to trade and sell items.) The most customized coverage which the serious collector can obtain is through membership in either the American Philatelic Society (stamps), or the American Numismatic Society (coins). Group coverage is also available through these organizations.

Sport equipment. This is another class which can present significant exposures. Large gun collections and their auxiliary equipment, as well as equipment used in other types of sport (archery, fishing, etc.) can be worth a significant amount of money. You may

need this coverage because a typical personal articles floater will only cover the guns themselves and none of the related equipment, (nor will it cover sports equipment of any other nature—archery or the like).

High-value fine art. For people who are fond of collecting fine art, the value of an individual item or the total value scheduled for all items may exceed the amount of coverage which standard property insurers are willing or able to provide. A number of excess and surplus lines brokerage houses provide coverage for these larger needs.

A vital consideration when considering a miscellaneous floater is whether or not it provides an agreed amount of coverage. Many of the specialty policies do provide coverage on this basis.

CONCLUSION

This chapter has shown you how to obtain a rough average of your total "worth"; that is, the sum of your personal belongings plus your potential liability. It's a good idea to have a general idea of these figures before you start researching policies and looking for one to fit your needs. It doesn't matter whether you're a strapping recent college grad or a middle-aged millionaire still paying rent. All of us have things to protect.

This chapter has also shown you that a variety of floater forms are available to fill some of these insurance gaps. Many classes of personal property may be insured under personal articles floaters or personal property floaters for higher amounts than are available under basic renters policies. Depending upon the

form used, coverage may be written on a scheduled (per item) basis or a blanket (per class) basis.

In the next chapter we'll take a closer look at the concept of liability and why it's such a major issue.

CHAPTER

4

LIABILITY ON
YOUR PART

When you decide about getting a renters policy, you are probably thinking about all those possessions that you can't afford to lose. But a renters policy doesn't just cover the tangible things you own; most policies have liability coverage built in. And this is **critical coverage** to have these days as more and more people file frivolous lawsuits and make life miserable for the hapless renter.

In Chapter 1 we saw how a young woman's loony neighbor took her to court over "personal care products" the smells of which floated over to his side of the unit and allegedly causing him "severe neurological damage." If she had not had any insurance, how would she have afforded the lawyer to defend her? Moreover, if she had been found liable for the man's physical ailments, how would she have paid for the judgment?

Answer: She would have had a hard time. She would have had to resort to measures like selling her assets, using her savings...perhaps even using her future income.

Just like you can't predict the occurrence of a peril, you can't predict when someone will decide to hold you financially responsible for something that happens—even if by mistake. This is what's scary about living today. Anyone can sue you and take away the very things you work so hard to acquire.

The liability portion of the policy is designed to protect assets if you are **sued by someone who is injured**—physically, mentally or otherwise—while on your rented property. Liability is also a very important aspect to homeowners insurance. Earlier in this century, governmental regulations prevented property insurance companies from selling liability insurance. (By the same token, liability insurance companies couldn't sell property insurance.) So, a homeowner had to purchase two or more policies, often from different insurance companies, to obtain total insurance protection.

Starting in the 1940s, these regulations were changed. Now, the **Homeowners Policy Program** provides liability automatically in addition to the property coverages. The combination of two or more types of coverage into one policy is called a **package policy**. A basic renters policy is also a package policy.

By combining property and liability coverages, the insurance company is able to reduce processing costs, determine losses more accurately, and pass these savings on to the consumer in the form of lower premiums.

The liabilities covered by homeowners insurance arise from civil—not criminal—law. Criminal law deals with conflicts between an individual's behavior and the state. Civil law provides a means by which one person or institution can sue another in order to protect private property or a right—which one party feels has been violated by the other.

JARGON OF LIABILITY ISSUES

If an accident occurs on your property, anyone who is hurt can **hold you financially liable** for the injuries they suffer. Most renters policies offer you liability protection for bodily injury and property damage. This coverage applies to the injured person's claim and the cost of defending you if you are sued.

The standard policy's liability protection covers injuries or damage caused by you, and anyone else who is a *named insured* in the policy. Pets are another story, which we'll get into later. The liability protection applies to injuries that occur on your property—or anywhere in the world.

If the named insured dies, coverage continues for legal representatives—but only with respect to the premises and property of the deceased. Until a legal representative is appointed, a temporary custodian of the named insured's property would also be covered.

All household members who are insured at the time of the named insured's death will continue to be covered while they continue to live at the residence premises.

> Who's insured is an important definition. In a stan-
> dard policy, the insurance company promises to
> pay any damages and provide legal defense for
> any insured. These are important benefits.

Bodily injury means harm, sickness, or disease and in-
cludes the cost of required care, loss of services or
death resulting from the injury. This is one of the main
kinds of loss that constitute a civil liability.

Property damage means injury to or destruction of tan-
gible property and includes loss of use of the prop-
erty. This is another of the main kinds of loss that
constitute a civil liability.

Occurrence means an accident (including continuous or
repeated exposure to conditions) which results in
bodily injury or property damage neither expected
nor intended by an insured person. A situation must
be deemed an occurrence before insurance will ap-
ply.

TWO MAIN LIABILITY COVERAGES

There are two kinds of coverage provided under the
liability section of a homeowners or renters policy.
These are identical on all policy forms—though they
will appear in different locations of specific policies.

> Renters policies, like most kinds of insurance, orga-
> nize the specific kinds of coverage they offer with a

letter system—Coverage A through Coverage Z, if
there are that many. But there's not much consis-
tency beyond that. One policy's Coverage A might
be the same as another policy's Coverage C, etc.
When you compare policies, look for the name of the
coverage in question—don't be confused by letters
that don't match up.

The first liability coverage is **personal liability** cov-
erage. This pays an injured person—usually a third
party—for losses that are due to the negligence of
the insured, and for which the insured is liable.

Example: Missy takes her dog out for a walk without
a leash. For no apparent reason, Missy's dog attacks
Ethelbert, who happens to be jogging nearby. The
attack results in injuries to Ethelbert that cost $20,000
in lost income during recovery. Missy is personally
liable to Ethelbert for this $20,000.

In a basic renters policy, the insurance company will
pay up to its limit of liability for the damages for
which the insured is legally liable; and it will provide a
defense at its expense even if the allegations are
groundless, false or fraudulent. The insurance
company's duty to settle or defend ends when the
amount it pays for damages resulting from the oc-
currence equals its limit of liability. The limit of liabil-
ity will be clearly indicated on the Declarations Page.
Typically this number is an amount of $100,000 to
$300,000, and you can increase your coverage from
$300,000 to $500,000 for less than $30 a year.

The second liability coverage is **medical payments** to others. This covers necessary medical expenses incurred **within three years** of an accident causing bodily injury. An accident is covered only if it occurs during the policy period.

Medical expenses include reasonable charges for medical, surgical, x-ray, dental, ambulance, hospital, professional nursing, prosthetic devices and funeral services.

This coverage **does not apply** to medical expenses related to injuries of the named insured or any regular resident of the insured's household, except residence employees.

At the **insured location**, coverage applies only to people who are on the insured location **with the permission** of an insured person. Away from the insured location, coverage applies only to people who suffer bodily injury caused by:

- an insured person;

- an animal owned by or in the care of an insured;

- a residence employee in the course of employment by an insured; or

- a condition in the insured location or the ways immediately adjoining.

In some cases, these costs are simply determined; in other cases, the facts may be unclear—and the insured person may or may not be legally liable. In these cases, the insurance company will often pay medical costs as a **goodwill gesture** to avoid any legal action.

A visitor to Ginger's home slips and falls on the front steps. These injuries result in medical expenses to the visitor in the amount of $575. Later, the visitor sues Ginger for $30,000, claiming damages for negligence. An insurance company will pay the $575 quickly, in hopes of preventing the larger lawsuit.

The insurance company has plenty of incentive to avoid lawsuits. Under the standard renters policy, it will provide a **legal defense against claims**—even if the claims are **groundless, false or fraudulent**. The company may also make any investigation or settlement deemed appropriate.

All obligations of the insurance company end when it pays damages equal to the policy limit for any one occurrence. But legal costs can add up quickly in the meantime.

Both personal liability and medical payments coverage have limits—medical payments is usually much lower than personal liability. If your liability limit is $100,000, your medical payments per person might be $1,000. Unless you ask otherwise, you'll get the **basic limits** of these coverages, which are the minimum amounts written. As ever, higher limits of liability can be purchased.

Personal liability insurance applies **separately to each insured person**, but total liability coverage resulting from **any one occurrence** may not exceed the limit stated in the policy.

If Claus and his brother are both walking the dog when it bites Ethelbert, they both might be named in a lawsuit. However, their insurance will only cover them up to the single limit. If Claus was involved in one dog bite and his brother was involved in another, the insurance would cover each up to the limit separately.

LIABILITY LOSSES NOT COVERED

Liability coverage on a renters policy does have its limitations. For example, a policy won't cover you for bodily injury or property damage that is **expected or intended** by you or any insured, or that is the foreseeable result of an **act or omission** intended by an insured. Thus, if you set your kitchen on fire because you really wanted to collect the insurance for a new set of china and a fancy refrigerator, you'll have a hard time getting the insurance company to pay. Even if this act results in serious injury to you and your accompanying friend, you won't get much help. Similarly, you can't make a claim for a loss **arising out of business pursuits** of any insured or the rental or holding for rental of any part of any premises by any insured. However, this last exclusion does not apply to:

1) activities that are ordinarily incident to non-business pursuits;

2) coverage for the occasional or part-time business pursuits of any insured who is under 23 years of age; and

3) the rental or holding for rental of a residence of yours on an occasional basis for the exclusive use as a residence... .

The exclusions to personal liability and medical payments are extensive in any renters policy. The following are some of the other exclusions typically listed. Note that these are portions of the exclusions; each policy will contain slightly different language and have nuances to every exclusion. Personal liability and medical payments do not apply to bodily injury or property damage:

- arising out of the rendering of or failing to render **professional services**;

- arising out of any premises owned or rented to any insured that is not an insured location;

- arising out of the ownership, maintenance, use, loading or unloading of aircraft, motorized land vehicles and watercraft (note: these are general exclusions, each one with further exceptions to the rule, so check your policy);

- caused directly or indirectly by **war**;

- arising out of the transmission of a **communicable disease** by an insured;

- which results from the legal liability of any insured because of home care services provided to any person on a regular basis;

- arising out of physical or mental **abuse**, sexual molestation or **sexual harassment**;

- arising out of the use, sale, manufacture, delivery, transfer or possession of a **drug**;

- arising out of any insured's participation in, or preparation or practice for any pre-arranged or organized race, speed or demolition contest, or similar competition involving a motorized land vehicle or motorized watercraft regardless of whether such contest is spontaneous, pre-arranged or organized.

The above list is short compared to what you'll find detailed in a policy. Personal liability does not apply to a long list of things, such as bodily injury to any insured. This means if you slip and fall in your own kitchen after you burn your hand, you cannot collect on your own policy. Remember: liability is to protect you from other people blaming you for their bodily injury or property damage. Medical payments to others also has its exclusions, so pay attention.

Mack's little sister decides to bunk with him for awhile. But Mack doesn't put her on the policy, and something happens to his sister one night during a party. When Mack looks closely at his policy, he reads that *medical payments to others does not apply to bodily injury to any person, other than a residence employee of any insured, regularly residing on any part of the insured location.* So she's out of luck.

There can be just as many exclusions to your coverage as there are inclusions, so read carefully. Some-

times the language can get tricky, so ask questions if you are unsure what certain phrases mean.

ADDITIONAL COVERAGES

The personal liability coverage provides three kinds of insurance in addition to the stated limits of liability:

- claim expenses;

- first aid to others;

- damage to the property of others;

- credit card, fund transfer, forgery and counterfeit money; and

- statutorily imposed liabilities (such as vicarious parental liability).

Claim expense coverage includes the costs of defending a claim, court costs charged against an insured person and premiums on bonds that are required in a suit defended by the insurance company. However, the policy won't cover bond amounts greater than the limit of liability for personal coverage.

Expenses incurred by the company, such as investigation fees, attorneys' fees, witness fees, and any trial costs assessed against you will be covered by the policy.

If any bonds are required of you in the course of a lawsuit, such as release of attachment or appeal bonds,

the company will pay the premium for such bonds but is under no obligation to furnish the bonds. That is your responsibility.

> When the insurance company requests the assistance of an insured person in investigating or defending a claim, reasonable expenses of the insured—including loss of earnings up to $200 per day—are covered.

Claim expense insurance also covers **postjudgment interest**, which accrues prior to actual payment. If a judgment is rendered against you, there usually is a time lapse between the rendering of the judgment and the payment of the damages awarded. The company will pay any interest charges accruing on the damage award during this time period.

Expenses for **first aid to others** are covered when the charges are incurred by an insured person—and when the charges result from bodily injury that is covered by the policy. Expenses for first aid to an insured person are not covered.

> You are authorized by the insurance company to incur expenses for first aid to an injured third party when there is bodily injury covered by the policy. It will cover your attempts to be a good Samaritan.

If **damage to the property** of others is caused by an insured person, the policy will provide replacement cost coverage on a **per occurrence limit**.

Example: You borrow a camcorder from your neighbor and accidentally drop it in your swimming pool while taking pictures. This coverage will provide up to $500 to replace the camera.

This additional coverage won't pay for:

- **damage already covered** by the policy;

- **damage caused intentionally** by an insured person who is at least 13 years of age (there has to be some cut-off age—otherwise, this would cover the intentional acts of insured adults);

- **property owned by you**, because this coverage is designed to cover property owned by others;

- **property owned or rented to a tenant** or a person who is resident in your household.

Exclusions to liability coverage do not end here. There are three major circumstances under which liability coverage does not apply. Any damage arising out of the following will not be covered:

- **business** pursuits;

- any **act or omission** in connection with a premises owned, rented or controlled by any insured, other than the insured location; or

- the ownership, maintenance, or use of **aircraft, watercraft or motorized land vehicles**.

The third exclusion here does not apply to a motorized land vehicle designed for recreational use off public roads, not subject to motor vehicle registration, licensing or permits and not owned by any insured.

The business pursuits exclusion is a major issue. Liability assumed under a written contract is covered, as long as the contract is personal in nature. There is no coverage for business-related contracts or activities.

In Chapter 9 we'll look at the issue of business pursuits in the home, and you can go about obtaining the right coverage for all that you do at home.

IDENTITY THEFT

More than 700,000 people were victims of identity theft in 2001, making it a **top complaint among consumers**. Many renters (homeowners and condo) policies have this kind of coverage built in so you don't have to seek standalone coverage. However, you can obtain standalone theft insurance coverage for as little as $25 annually, which will cover you up to $15,000 in expenses with a $100 deductible. Some homeowners policies with built-in coverage of this kind provide $25,000 in coverage with a $500 deductible.

Low-cost personal insurance coverage for identity theft is available from some insurance companies, which will cover you for things like attorneys' fees, notary and certified mailing costs, loan reapplication fees,

phone charges and lost wages for time taken off of work to deal with the problem. But if you already have a renters or homeowners policy, having additional coverage isn't so necessary. Although the coverage won't be as extensive, most policies today have plenty of identity theft coverage built in to them to protect you from the majority of fraud.

Under a basic renters policy, for example, the insurance will pay up to $1,000 for:

- the legal obligation of any insured to pay because of theft or unauthorized use of credit cards issued to or registered in any insured's name;

- loss resulting from theft or unauthorized use of a fund transfer card used for deposit, withdrawal or transfer of funds, issued to or registered in any insured's name;

- loss to any insured caused by forgery or alteration of any check or negotiable instrument; and

- loss to any insured through acceptance in good faith of counterfeit U.S. or Canadian paper currency.

You cannot, however, entrust another resident in your household with your credit card or fund transfer and expect to recoup any losses from an abuse of that entrustment. Nor can you make a claim for a loss resulting out of **business pursuits** or **dishonesty on your part**.

> All losses resulting from a series of acts committed by any one person or in which one person is concerned or implicated is considered to be one loss. At an estate sale, you sell a $5,000 Picasso print and a $3,000 armoire to the same person, who uses fake money to purchase the items. Even though it's two losses to you, the insurance company lumps them together under one loss from the same person.

The insurance company retains the right to make any investigation and settle any claim or suit it decides to appropriate. If the roles are reversed and you are the one accused of something like credit card or fund transfer fraud, your insurance will defend you at its expense and by the counsel of its choice.

Statutorily imposed liability may vary from policy to policy, and from state to state. A common one is **vicarious parental liability**, which is created by a minor or other dependent for whom an insured person acts as guardian. In most cases, the guardian can be held liable for the minor's behavior—even though the guardian played no direct role in the loss. A teenager who participates in a party and causes damage while at the party implicates his own parents when it comes to liability—even when the parents had no idea about the party and it took place outside the home.

A renters policy may stipulate that this type of liability coverage pays the statutorily imposed limit or $3,000, whichever is less.

> If you're only worried about credit card fraud, the most common form of identity theft, consider asking your credit card companies to place a "credit watch" on your records. Credit watch is monitoring your particular credit file, so if there is a change, it gives you early indications if there's potential fraud; if a change is made to your account, you will be notified within 24 hours so you can either verify or dispute it.

The credit agencies Equifax, Experian and Trans Union offer a version of the credit watch program for a fee (See Chapter 9 for information about these agencies.) The credit watch doesn't cost anything, but you can only have it enacted if someone has stolen your identity.

LIABILITY LIMITS

A **limit of liability** exists for on-premises coverage. This limit is the most the insurer will pay for any one covered loss at the described location. On-premises coverage applies while the property is:

- at the described location occupied by an insured person;

- in other parts of the described location not occupied exclusively by an insured person (if the property is owned or used by an insured person or covered residence employee); or

- placed for safekeeping in any bank, trust or safe deposit company, public ware-

house or occupied dwelling not owned,
rented to or occupied by an insured per-
son.

This type of insurance limits coverage either with one
general dollar limit or a range of **dollar limits** ac-
cording to the type of personal property. In the first
case, a policy would insure all your property—regard-
less of type—to a limit of $20,000. In the second, a
policy would insure computer equipment up to $5,000,
stereo equipment to $2,000, sports equipment to
$1,500, etc.

Although limits of liability are shown for the maxi-
mum amount of insurance for any one loss, special
sub-limits of liability usually apply to specific cat-
egories of insured property. Each limit is the most
the insurer will pay for each loss for all property in
that category. Ask your insurer about the sub-limits
of liability that apply to your policy. In Chapter 3, we
went over some of the most typical limits of liability
for things like money, silverware, jewelry, furs and
firearms. Refer back to pages 56 and 57 for the list.

If you purchased a new computer for $10,000 and
your policy has a $3,500 limit, you may want to
shop for a new policy or buy a floater to cover the
computer's full value.

Renters policies have similar limits. The policy is in-
tended to provide basic coverage for special items
of value that may be subject to theft. Most policies
will not allow the full limit of liability to be applied to
a specific kind of property.

MISCELLANEOUS CONDITIONS

The liability coverage in a renters policy includes a number of other conditions, which can limit its applicability. These conditions include:

- The **bankruptcy or insolvency of an insured** person does not relieve the insurance company of its obligations under the policy.

- Personal liability coverage will be treated as **excess over any other valid and collectible insurance**—unless the other insurance is written specifically to be treated as excess over the personal liability coverage.

- Your duties in the event of a covered occurrence include **providing written notice** identifying the insured person involved, your policy number, names and addresses of claimants and witnesses, and information about the time, place and circumstances of the occurrence.

- You are also required to promptly forward every **notice, demand or summons** related to the claim and, when requested, to assist in the process of collecting evidence, obtaining the attendance of witnesses and reaching settlement.

- You are not supposed to **assume any obligations** or **make any payments** (other than first aid to others following a bodily injury), except at your own expense.

- Payment of medical costs to others is **not an admission of liability** by you. When medical payments are made, the insured person or someone acting on behalf of the injured person has to provide written proof to support any claim. The **injured party** must submit to a physical examination, if requested by the insurance company, and authorize the company to obtain medical reports and records.

Also outlined in this section of the policy are instructions for what you need to do in the event of an accident or occurrence. We'll go into these details in a later chapter.

MISCELLANEOUS EXCLUSIONS

There are several exclusions to liability coverage, some of which are listed above. Business pursuits is obviously the biggest issue for renters who have home-based businesses or freelance at home outside of their usual 9-5 job. Personal liability coverage is not a business policy—it will only cover personal activities and exposures. The standard policy form itself states:

> Any liability arising purely out of the insured's occupation or business and/or the continual or permanent rental of any premises to tenants by the insured is excluded.

However, there are some activities that can be construed as business activities but are specifically covered under the policy as **exceptions to the exclusion**. Among these:

...the insured may rent out the residence and be covered by the policy under limited circumstances... .

...A portion of a residence might be used for professional purposes, such as a beauty parlor or physician's office...there is no coverage for professional liability arising out of these activities.

Injury to members of the insured household constitutes another major issue, as lawsuits between people covered by the same policy are excluded.

Before this exclusion was added to the standard policy, some courts permitted family members to sue other family members and collect damages.

Take this scenario for an example: A mother spills a pot of boiling water on her son by mistake, seriously injuring him. The father contacts the family's insurance carrier and seeks recovery against the policy for his wife's accidental injury of their son. Based on the **household exclusion**, the insurance company denies coverage. There'd be no medical payments coverage for their son through their renters insurance.

A renters policy is not meant to be a substitute for accident and health insurance—and this exclusion makes it clear that there is no coverage for an injury suffered by the named insured or other family members who reside in the same household.

Finally, **intentional acts of an insured person** or acts that can be expected to produce bodily injury or property damage are not covered.

> If you mean to hurt someone, your renters insurance won't cover damages. If you beat your wife and she turns around and sues you for damages, don't expect your insurance company to cover—or defend—you.

VEHICLE LIABILITY

One of the most dangerous activities you can undertake is driving a motorized vehicle. And the dangers posed aren't just personal—**vehicle accidents** are the most common cause of **liability claims** that most people face.

Since homeowners and renters insurance is a major means of liability protection, a reasonably smart person might suppose that vehicle accidents and homeowners insurance come together in a lot of **liability claims**. They do. In fact, they do often.

> Some people buy minimal amounts of auto insurance and hope their homeowners or renters insurance will cover any shortfalls. Insurance doesn't work that way.

Renters insurance **does not apply** to any exposure—even liability—created by driving **any vehicle that is**

registered and tagged with a state motor vehicle administration. There is also no coverage for liability arising out of vehicles that you **own, operate, rent or borrow**. These vehicles should be covered by an auto policy.

However, you might find coverage for the **vicarious liability** created when a member of your household drives someone else's vehicle.

Example: If you are sued for damage caused by your 12-year-old daughter who went joy riding with your car, there is no coverage under your policy's vicarious liability exclusion. If she borrowed a neighbor's car, though, there would be coverage.

Liability involving the following types of unregistered vehicles is covered under a standard renters policy:

- a **trailer** not towed by or carried on a motorized land vehicle;

- an **off-road recreational vehicle** that you rent, borrow or own—as long as it is used only at an insured location;

- damage or injuries involving **golf carts**, when used for golfing; and

- motorized **lawn mower tractors, electric wheelchairs** and **similar vehicles** in dead storage are covered.

The **watercraft exclusion** is very similar to the motor vehicle exclusion. **Larger boats** are more appropriately covered by boat or yacht policies.

However, liability claims involving the following types of boats are covered:

- **motorboats** with **inboard or inboard-outboard motors** that you don't own;

- **motorboats** with outboard motors of greater than 25 horsepower that **you have owned since before inception of the insurance** contract—as long as the insurance company is notified of the exposure;

- **motorboats** with outboard motors of greater than 25 horsepower that you acquire during the policy period;

- sailboats that you own—as long as they are **under 26 feet** in length (the standard renters policy will cover bigger sailboats, as a long as you don't own them); and

- boats in storage, regardless of size.

Some of these exact terms will vary among policies. If you own a boat of any kind, it's best to ask your insurance agent if it's covered and by how much. Give specifics as to size, horsepower and use. For the most part, boats should be insured under a separate policy—especially if it's something you use on a regular basis away from your home.

The standard renters policy includes an **aircraft** exclusion similar to the other vehicle exclusions. A **hang glider** would be considered an aircraft, and would be excluded since it is designed to carry a person.

On the other hand, liability involving **model planes**, including remote-controlled model planes, is covered.

DOG OWNER LIABILITY

Owning a pet can be hazardous to your health—as well as the health of others in today's lawsuit-happy world. If you own a dog, this is one more reason to get renters insurance. Without insurance, victims of dog bites (no matter how small) and their lawyers will go after your personal assets. For most, such a suit could be financially devastating.

> Insurers pay out $310 million a year in dog-bite liability claims; 15 to 20 people die from dog bites each year in the U.S., the majority of them children. According to the Centers for Disease Control and Prevention, there are 4.7 million dog bites in the U.S. each year, and they cost a staggering $1 billion overall. A dog owner can be found liable for a victim's medical expenses, lost wages, pain and suffering and, even in some cases, psychiatric therapy for trauma.

Canine liability has gained considerable attention since the January 26, 2001, mauling death of Diane Whipple in San Francisco. Whipple was killed by a Presa Canario while on her way home from work. In the case that followed, *People of the State of California v. Robert Noel and Marjorie Knoller*, the owners of the dog were found guilty of involuntary manslaughter and owning a "mischievous" animal. At first, the jury convicted Marjorie Knoller of second degree murder, which was later thrown out. Now she is serving four years in prison and has a stack of legal bills to pay. The case added to the growing fear that dogs can be

a major financial liability. And insurance companies have responded.

If you own a dog and assume that your policy covers your pet, double-check the language and ensure that your policy doesn't exclude coverage—particularly your **breed of dog**. Insurance companies keep lists of dangerous dogs and some of them can be uninsurable. Although many companies won't readily admit to having these lists, based on dog-bite fatality statistics, many will deny or cancel coverage of landlords and individual tenants who have pit bulls, German shepherds, Rottweilers, malamutes, Doberman pinchers and Saint Bernards.

You may have to apply for additional insurance to cover your pet. Or, you may have to seek insurance with another carrier if your current one happens to exclude canine liability. Don't think that every renters policy will automatically cover a pet. Ask your agent questions and be willing to pay more to cover your pooch if he or she is worth it!

A CASE OF LIABILITY

The 2001 Maine district court case *North River Ins. Co. v. Snyder* considered a common case of renters liability. Although the crux of this case regards the property owner's policy and how it affects tenants, it's important to realize that even when you're covered by a renters policy and you know that your landlord is covered by his own policy, something gone wrong in your abode could mean that the landlord (or in this case, his insurance company) comes after you for damages. In such a case, it's called a **subrogation for insurance benefits** paid.

Denzil and Candice Snyder moved into the Cortland Court apartment complex with their two children in March of 1998. They took out a renters policy with Concord Insurance, which covered their personal property and provided $300,000 in liability protection. Candice Snyder's brother also lived in the building with his fiancé, Valerie Swetavage, and their son. Both couples had identical lease agreements and the building itself was insured by North River Insurance Company. Swetavage and her fiancé did not have a renters policy.

Beginning in 1997, Swetavage volunteered to watch over the Snyders' children during the work day after the former babysitter moved away. On April 30, 1999, she went over to the Snyders' apartment to babysit their children as well as her own son. She could have picked either place to watch over the three children, but chose to do so at the Snyders' place.

A fire started on the outside deck after Swetavage smoked a cigarette. North River Insurance paid a claim. Although the Snyders, who were not at home during this event, contend that the cigarette was not the cause of the fire, the fire department concluded that the fire was in fact caused by the careless discarding of a cigarette on the deck. Who's responsible?

Although the insurance company for the building paid a claim, it came back to try and recoup its loss from the Snyders. North River alleged that the lease "expressly and unequivocally provides that the Snyders would be responsible for any damages to the premises caused by their negligence or that of their guests or invitees." The company cited a paragraph from the lease agreement:

> Tenant's Responsibility: The Resident is responsible for the conduct of any and all family members, friends, relatives, delivery personnel, guests and other persons who are invited or allowed by the Resident to be on the Landlord's property. The Resident must make sure that these persons conduct themselves properly and do not violate any provisions of this Lease. Whenever the Landlord has to pay any expense, or suffers any other loss, because of anything done by the Resident or any other person mentioned in this paragraph, the Resident must promptly provide full reimbursement to the Landlord.

North River argued that the lease's language made the tenant liable for certain costs incurred by the landlord and not excluding fire damage. The court, however, disagreed, pointing to the fact that the language in the lease agreement fails to mention insurance and cannot be construed as an express agreement concerning insurance or liability for fire damage in particular.

The insurance company's attempt to pin the liability on the Snyders is a classic case of subrogation, which is, the court articulated, "a device adopted by equity to compel the ultimate discharge of an obligation by him who in good conscience ought to pay it." Because the damage was caused by an invited guest of the Snyders and by a careless act, North River didn't want to pay. But the court had to look at all the facts and determine whether subrogation could apply here.

It wrote:

> Certainly it would not likely occur to a reasonably prudent tenant that the premises were

without fire insurance protection or if there was such protection it did not inure to his benefit and that he would need to take out another fire policy to protect himself from any loss during his occupancy.

Basic equity and fundamental justice upon which the equitable doctrine of subrogation is established requires that when fire insurance is provided for a dwelling it protects the insurable interest of all joint owners including the possessory interests of a tenant absent an express agreement by the latter to the contrary. The company affording such coverage should not be allowed to shift a fire loss to an occupying tenant even if the latter negligently caused it. For to conclude otherwise is to shift the insurable risk assumed by the insurance company from it to the tenant—a party occupying a substantially different position from that of a fire-causing third party not in privity with the insured landlord.

In all, the court disagreed with the property owner's insurance company and sided with the Snyders.

CONCLUSION

One of the most important reasons to purchase homeowners insurance is for liability coverage. This coverage takes shape in two parts: personal liability coverage and medical payments coverage.

If damage was caused by you, your spouse, children or pets to an other person or persons on the premises of your home—you can be held liable.

Liability coverage is often an automatic addition to basic renters policies because liability insurance has become so important in the modern marketplace. When liability coverage is not attached to a renters policy directly, it's sometimes written as a separate policy.

It is important to know the different **definitions of liability** and how they apply to you legally. It is also important to know when limits of liability occur in your insurance policy and the insurance company stops paying. The next chapter discusses not only the important definitions that apply to liability, but it will also focus on numerous definitions that are important to renters insurance as a whole.

5

IMPORTANT
DEFINITIONS

If you're not accustomed to insurance terminology, then you're likely to encounter some funny words and language in your policy for which you may not be able to turn to Webster for help. Renters insurance, like any other type of insurance, has its own language.

Before you can file a claim or even find coverage you must first understand the **language common to renters policies** (and most homeowners policies). And because each line of insurance interprets its policies and definitions differently, it is important to understand how the language and basic concepts pertain to your specific policy.

This chapter details some of this language by providing an alphabetical list of the most basic terms and policy language found in renters insurance.

ACTUAL CASH VALUE

Generally, **actual cash value** means the market value of new, identical or nearly identical property, less reasonable deduction for wear and tear, deterioration and obsolescence. If you've chosen this kind of in-

surance, most policies will state that when the damage to property is **economically repairable**, actual cash value means the cost of repairing the damage, less reasonable deduction for wear and tear, deterioration and obsolescence. On the other hand, when the loss or damage to property creates a **total loss**, actual cash value means the market value of property in a used condition equal to that of the destroyed property, if reasonably available on the used market.

> **For example:** You lose your 1993 Bang & Olufsen stereo in a fire. But today it's only worth a fraction of your purchase price. Actual cash value will only get you that fraction with which to go shopping for a new stereo. Because there is little cost difference between a policy that stipulates actual cash value and one that covers replacement cost, it's best to choose a policy that will replace your possessions. (Then you'll be able to purchase a new Bang & Olufsen.) See Replacement Cost.

BODILY INJURY

This refers to **bodily harm, sickness or disease**, including required care, loss of services and resulting death. Bodily injury coverage, which is found in the liability portion of a renters policy, does not include any communicable disease transmitted by an insured to anyone else. Note that bodily injury and **personal injury** are two separate things. Bodily injury simply refers to physical injury, while personal injury includes bodily injury and also nonphysical injuries like libel, slander, illegal discrimination and defamation. See Personal Injury.

BUSINESS ACTIVITIES

Business means any trade, profession or occupation. **Business activity** is any agreement, contract, transaction or other interaction that advances your occupation. These terms are important because, in most cases, renters policies limit coverage for businesses and business activities.

In a standard policy, business-related property is insured up to a few thousand dollars.

> Business-related liability is a more complicated issue. Liability coverage for business-related activities is strictly limited. Any significant business exposure should be covered under a separate commercial policy.

See Chapter 9 for more information on business coverage.

CANCELLATION

You may cancel a policy at any time and for any reason. You simply have to notify the company in writing. You must send a **notice of cancellation** to your insurer a prescribed number of days before it becomes effective.

However, the company may cancel a policy only at certain times and for certain reasons.

CLAIM EXPENSE

Claim expense coverage includes the **costs of defending a claim**, court costs charged against an insured in any suit the insurer defends, and premiums on bonds that do not exceed the coverage limit and that are required in a suit defended by the insurer. When the insurer requests the assistance of an insured in investigating or defending a claim, reasonable expenses of the insured, including loss of earnings up to $50 per day, are covered. Claim expense insurance also covers post-judgment interest that accrues prior to actual payment.

COLLAPSE

The dictionary definition of **collapse** is to "fall into a jumbled, unorganized or flattened mass." Despite this simple definition, several court decisions have interpreted collapse as the "loss of structural integrity." That less exact definition causes a number of disputes. Collapses, whether partial or complete of a building, are covered perils in a renters policy. This peril usually does not include settling, cracking, shrinking, building or expansion.

CONCURRENT CAUSATION

Concurrent causation is a term that refers to a situation where **two or more perils act concurrently** (at the same time or in sequence) to cause a loss. This can create significant problems for insurers when one of the perils is covered by a policy and the other peril is not.

An example of **concurrent cause**: A hurricane causes a great deal of surface flooding in the back yard of your rented house. As a result of this, the ground around your swimming pool partially gives way and the pool cracks. This is a case of a weather condition combining with an excluded peril—earth movement—to produce a loss. It is not covered.

CONSIDERATION

The most important element of a contract is the legal concept known as **consideration**—which means, simply, that one party gives something to another party in return for some thing or service.

In an insurance contract, the insured person makes a **premium payment** (consideration now) and promises to comply with the provisions of the policy (consideration future). In return, the insurance company promises to **pay covered claims** that occur during a stated policy period.

CONTRACT

An insurance policy is a **legal contract** or agreement between the insured and the insurance company. If anything should ever go wrong with a policy you buy, the rules of contract law will apply to a lawsuit or other action. The insurance company is one party to this contract, and the person buying the insurance becomes the other party. Generally, the terms of the contract require the person who buys the insurance (called the *insured*) to pay money (the *premium*) to the insurance company (the *insurer*)—and, in return, the company agrees to pay the insured for certain specified losses over the period of time the insurance is in effect.

COVERAGE

The scope of protection provided by an insurance policy is called **coverage**. The policy spells out many agreements, but perhaps most important, it specifies the type of losses for which the insured will be reimbursed by the insurance company. When the policy states that the insurance company will pay for a certain type of loss, then it is common to say that the insured person **has coverage** for that loss.

DEBRIS REMOVAL

Coverage for **debris removal** is, surprisingly, a common the cause of many disputes between insurance companies and policy owners. When there is a fire or other type of loss of any consequence, there will be a certain amount of debris to be removed or cleaning to be done as part of the repair operations.

These costs are included in the claim amount as long as there is sufficient coverage to pay for the damaged property plus debris removal. If combined loss exceeds the policy limit, then an additional amount of coverage equal to 5 percent of the limit of liability will be made available for debris removal.

> In addition to debris removal, policies will also pay the reasonable expenses you incur, up to a limit of around $500, for the removal of trees from the residence premises, provided the trees damage covered property. The $500 limit is the most an insurance company will pay in any one loss regardless of the number of fallen trees.

DEDUCTIBLE

In order to avoid nuisance claims, insurance companies request that most policies have a **deductible**—an initial amount an insured person must pay before the insurance company takes over. For most renters policies, this deductible will be a few hundred dollars, typically $250. The higher the premium, the lower the deductible—and vice versa. Sometimes a policy owner can **buy back** a lower deductible by paying a higher premium or special one-time fee.

DUTY TO DEFEND

The insurance company has the right and the option to investigate and settle any lawsuit and claim. In the same process, it also accepts a **duty to defend** an insured person in any related lawsuit or claim. But, once it pays the limit of its liability to settle a suit or claim, it is no longer obligated to provide any further defense.

EARTH MOVEMENT

Earth movement means landslide, mudflow, earth sinking, rising, or shifting and earthquake including land shock waves before, during or after a volcanic eruption. This term also includes "mine subsidence." If direct loss by fire, explosion or breakage of glass parts of a building, storm door or storm window follow earth movement, the policies will cover the additional loss, and that loss only.

ENDORSEMENT

Most insurance policies are printed in great quantities as **standard forms**. Since there are many variations in

the protection needed by individual consumers, a means to add or delete coverages is necessary. Whenever a basic policy form is changed in any way, this change is put into effect by an endorsement. An endorsement often involves a premium change. In renters policies, endorsements are often referred to as **riders** or **floaters**.

EXPIRATION

The end of the coverage period defined in the insurance policy is the **expiration date**. If the policy is not renewed by this date, premiums and coverage both stop. However, expiration is not absolute—it does not affect payments for loss of use. If a loss occurred just before the expiration date of the policy and continued for two months after expiration, the loss would be fully covered.

EXPLOSION

Explosions can be caused by the ignition of explosive material such as natural gas or the fumes from gasoline, usually in an enclosed space or from the buildup of pressure within a container. Gas from a leaking line can be ignited by a pilot light, or fumes from cleaning clothing in an unaired room can explode.

Internal explosion means explosion occurring in a dwelling or other covered structure. It does not include breakage of water pipes or loss by explosion of steam boilers or steam pipes. This peril will provide coverage for an explosion where a fire doesn't ensue—but explosions and fires are usually closely related.

FAIR RENTAL VALUE

If you suffer a loss in your apartment that affects a room you rent out to someone else (i.e. sublet), your policy will cover you for the **fair rental value** of that room.

> Example: You have an extra room in your apartment that you sublet out to someone else. A serious fire occurs that makes your residence uninhabitable, and your roommate is forced to seek a room elsewhere. As a result, you lose the income from the rental during the two months it takes to repair the residence. The company will reimburse you for the lost rental less any expenses associated with the rental that do not continue, such as utilities. Most policies limit the time of this coverage, say the shortest time required to repair or replace the damage or 12 months—whichever comes first.

FALLING OBJECTS

This peril does not include loss to property contained in the building unless the roof or an outside wall of the building is first damaged by a falling object.

Damage to the falling object itself is not covered.

Falling objects can be anything from a meteorite to a part of an airplane. But it has to penetrate the outer wall or roof of your rented place before the personal possessions damaged inside are covered.

FIRE

Fire is a covered peril in a renters policy, alongside lightning. But there is no real definition of fire, and it is a major point of dispute between insurance companies and policy owners.

In the insurance industry, there is a technical and legal definition of the term *fire*: a product of combustion that produces flame, light and heat. This definition helps to determine whether damage has been caused by *fire* or other perils, such as *explosion* or *smoke*. Heat damage done to your possessions near a wood heating stove would not be covered. If a spark from a fireplace shot out and caught the drapes on fire, there would be coverage.

In order for smoke damage to be covered, it must be sudden and accidental. An example: You leave a roast unattended in the oven while you run a quick errand. Upon returning, you find that a small fire has broken out in the oven and heavy smoke has damaged draperies and upholstered dining room chairs. The expensive cleaning and smoke removal would be covered.

Another interesting note about fire: renters policies usually cover **fire department service charges**. These would be for your liability assumed by contract or agreement when you call the fire department to come save or protect covered property. This limit is around $500. But if you live in a city, municipality or protection district that furnishes fire department responses, your policy may not cover you.

FORM

An insurance policy, sometimes called a **form,** is the **written statement** of a contract of insurance. Legally, a policy is a contract between the insurance company and the person buying insurance.

FREEZING

Under standard policy terms, losses resulting from **freezing** are covered while the dwelling is unoccupied as long as heat has been maintained in the building or the water supply has been shut off and the plumbing system and appliances have been drained. Losses caused by freezing (of a plumbing, heating, air conditioning or automatic fire protective sprinkler system, or of a household appliance) while the dwelling is occupied are usually covered.

GENERAL EXCLUSIONS

General exclusions are broad in scope and deal with perils that affect a large number of households at the same time. Perils such as earth movements, floods, nuclear incidents and war are some of the principal general exclusions.

Whether the loss is caused directly or indirectly by these excluded perils, there is no coverage.

Also, if losses resulting from the perils excluded by the general exclusions occur with perils covered under the policy, either at the same time or in a prior or later sequence, there will be no coverage. An example: Due to an earthquake, several pipes are broken and water damages walls, floors and personal property.

Normally, the water damage is covered, but because it occurred in connection with an earthquake, no coverage applies.

HOMEOWNERS POLICY

A **homeowners policy** is a complete package of property and liability coverages designed to cover the average residential and personal exposures of most individuals and families.

> Homeowners policies are more extensive than renters policies, but they share similar language and formats. The main difference: renters only have personal property and liability exposures and don't need to insure their dwelling. Unlike renters insurance, homeowners insurance covers the value of the home—not just the physical property. In other words, the insurance covers risks and liabilities that might encumber the value of the property.

INDEMNIFICATION

Indemnification for a loss may be payment in money or replacement of the property. Stolen property may be returned to the insured, and payment made for any damage, or the company may keep the property and pay the insured an agreed or appraised amount.

INJURY

In the liability sections of a renters policy, **bodily injury** is defined as something different from personal

injury. Bodily injury means physical injury, and includes the expenses that might occur as a result of the physical harm, sickness or death.

Personal injury includes bodily injury and also non-physical injuries like slander, defamation of character, invasion of privacy, wrongful eviction or wrongful entry.

INLAND MARINE

The term **inland marine** insurance as it relates to personal coverage encompasses property that has special coverage needs for one or both of the following reasons: it is mobile; and its value is intrinsic or market-driven. Jewelry and furs, for example, can come under inland marine. Most renters policies, however, don't use this term in their policies.

INNOCENT SPOUSE DOCTRINE

Some states apply an **innocent spouse doctrine** to insurance policies. This doctrine holds that, if one spouse is not involved in and is unaware of activity in which the other spouse has engaged that nullifies the contract, the innocent spouse must remain insured.

Some insurance companies write their policies to state specifically that the **misconduct of any insured bars recovery by any other insured**. Courts frequently back up the insurance companies in these disputes.

INSURABLE INTEREST

Insurable interest is any interest a person has in a possible subject of insurance, such as a rental unit and

its contents, of such a nature that a certain happening might cause that person financial loss.

INSURED

An **insured** is a person granted coverage under the policy without actually being named. Insureds include: the named insured (you), relatives—especially minors who are in the care of any insured—resident in the household, and others as defined by the policy. The company promises to **pay any damages and provide legal defense** for any insured.

The standard definition of insured applies to various liability coverages. It is extended to persons responsible for animals or watercraft covered under the policy.

Example: You lend your Clydesdale to a local service organization to pull a wagon in a Memorial Day parade. During the parade, the horse bolts and injures a spectator. This policy will cover you—as the named insured—and the service organization for any liability.

INSURED LOCATION

Insured location is a sweeping definition that frequently applies to liability coverages. It includes all of the following:

- the **residence premises**;
- that part of any other premises, **other structures and grounds**, used by the named insured as a residence which is

either shown in the declarations or acquired during the policy period;

- any premises used by the named insured in connection with the residence premises or a **newly-acquired premises**;

- any part of a non-owned premises where an insured person **temporarily resides**;

- **vacant land** owned by or rented to an insured person (but not farm land);

- individual or family **cemetery plots** or **burial vaults** of any insured person; and

- any part of a premises occasionally **rented to any insured person** for other than business use.

INSURING AGREEMENT

The **insuring agreement** typically follows the Declarations page, stating that the insurance company will pay claims and provide coverage as described in the policy if you pay the premiums when due and comply with all the applicable provisions outlined. Some insuring agreements include the exact time that the policy term begins (inception date) and ends (expiration date), typically at 12:01 A.M. standard time at the location of the property involved. In some states, the policies are written to begin and end at noon, standard time. The agreement clarifies that the policy applies only to losses occurring during the policy period.

INTENTIONAL LOSS

The meaning of **intentional loss** is the subject of many arguments between insurance companies and policy owners. The standard renters policy does not cover intentional losses (insurance policies of any kind usually don't). This exclusion makes it clear that the policy is not designed to cover damage caused intentionally by an insured person. To do so would create a **moral hazard**—an incentive to cause a loss.

INTEREST (FINANCIAL)

Prejudgment interest is an additional amount of damages awarded to a plaintiff to compensate for the delay between the time of injury or damage and the time a judgment is made. Because liability claims may take months or years until an award is made, this amount is designed to replace the amount of interest the plaintiff would have earned had the damages been awarded at the time of injury or damage.

Postjudgment interest applies when a decision is made in favor of the plaintiff, but an appeal delays payment of damages. Postjudgment interest is money the plaintiff would have earned if the judgment had been paid at the time of the first judgment, before the appeal.

LIABILITY INSURANCE

Liability insurance is known as "third party" coverage, because it is designed to pay damages suffered by others when you are responsible. For this reason, injuries suffered by you or your family members are not covered.

If your best friend comes over for dinner, drinks too much wine, slips and breaks her leg in your doorway as she leaves, you are liable—and your policy will cover you. But if you are the one who slips and falls, you won't be able to collect money from your insurance company to help pay your medical bills.

LIABILITY LIMIT

The **liability limit** on the policy is the maximum amount that will be paid for any **one occurrence**. (An occurrence is defined as an accident or an exposure to substantially the same conditions over a period of time that causes an injury.)

The policy limit of liability is not increased because there is **more than one insured** person, nor is it increased because there is **more than one claim** or claimant as a result of a single occurrence.

LIBERALIZATION

In a standard homeowners policy, the insurance company agrees to apply automatically any changes in its standard terms that expand coverage. A **liberalization clause** may not apply to changes implemented through introduction of a subsequent edition of the policy.

Example: Shortly after you buy a renters policy, the special limits on certain types of personal property are broadened. For instance, the limit applying to

theft of trading cards and rare coins is increased from $2,000 to $3,000. You automatically get the $3,000 limit of protection even through your policy reads $2,000.

LIGHTNING

Lightning is a peril that is usually thought of as damaging to real property; however, if a lightning bolt hits a dwelling's electrical system, it can damage television sets, computer equipment or other electronic equipment. This type of damage is covered even if there is no ensuing fire.

LIMITS OF LIABILITY

Every policy—standard or customized—will include the maximum amounts that the insurance company will pay to cover various kinds of loss. These are the policy's **limits of liability**.

The limits will usually apply on a **per occurrence basis**, which means they focus on each loss—rather than how many insured persons or claimants were involved.

The limits don't necessarily describe the absolute limit of coverage provided by the policy. If several occurrences fall in a given coverage period, the policy will cover up to the limit several times.

LOSS (TYPES OF LOSS)

Many of the major coverages, such as coverage for personal property, provide insurance for direct losses.

Direct loss means actual physical damage, destruction or loss of property. Fire damage and stolen merchandise are examples of direct physical damage or loss.

Intentional Loss is the subject of many arguments between insurance companies and insureds. This exclusion makes it clear that the policy is not designed to cover damage caused intentionally by the insured. To do so would create a moral hazard.

MEDICAL PAYMENTS

Medical payments are a form of liability coverage. Paid to people injured by an insured person, they are provided with a **per person limit**—which is the maximum amount payable to one person arising out of one occurrence. There is **no limit** on the number of claims arising out of an occurrence, nor is there an aggregate limit on the amount payable. Typical renters policies have a $1,000 limit per person for medical payments.

MISREPRESENTATION

When any party to an insurance contract misstates a matter of fact, it has made a **misrepresentation**. This can be grounds for nullification of the policy—or damages in excess of policy limits.

Example: An applicant who has been canceled by previous carriers for excessive claims and does not show this on the application is making a material

> misrepresentation, since the carrier would probably not issue a policy if this information was known. In such cases, the contract could be voided by the company and any claim denied.

NAMED INSURED

A **named insured** is the person or persons whose name or names appear on the insurance policy form. "You" and "your" refer to the "named insured" shown in the Declarations and the spouse if a resident of the same household. "We," "us" and "our" refer to the company providing this insurance.

A named insured is different from an insured or an insurable interest under the policy. A named insured is the person whose name appears on the front of the policy—and the spouse, whether named on the front page or not, as long as he or she lives in the same household. (More than one named insured can appear on the front page.)

An insured could be a relative residing with the named insured or a guest of the named insured.

OCCURRENCE

An **occurrence** is usually defined as an accident, or an exposure to substantially the same conditions over a period of time, which causes property damage or bodily injury.

Example: You use Drano over the course of a year to help unclog your rented townhouse's bathroom sink. Over time, this usage destroys the shared pipes

of your neighbor's townhouse—and he wants you to pay for it. This would be considered a single occurrence.

Pay attention to the way in which occurrence is defined in any policy you sign. Insurance companies that don't want to pay claims will sometimes make tortuous arguments that whatever went wrong doesn't qualify as an occurrence.

PERIL

The actual cause of a loss is called a **peril**. Fire, lightning, explosion, windstorm, vandalism and theft are all perils. Insurance policies distinguish between *covered perils* (also called *perils insured against*) and *non-covered perils*. By definition, perils are "causes of loss."

Most property insurance policies insure against perils rather than hazards.

PERSONAL INJURY

Personal injury means injury arising out of false arrest, libel, slander, defamation of character, invasion or privacy, and other offenses that could result in a personal liability claim. These other offenses can include **false arrest**, detention or imprisonment and **malicious prosecution**.

Coverage for personal injury has its limitations. Coverage does not include injuries arising out of any illegal act committed by or at the direction of any insured; injury arising out of the business pursuits of any insured; injury arising out of civic or public activities performed for pay by any insured; or punitive damages awarded against any insured.

PERSONAL ARTICLES FLOATER

The **personal articles floater** (PAF) is a basic form used to insure certain classes of personal property on an itemized and scheduled basis, particularly if your basic policy won't cover these items. It is virtually identical to the "Scheduled Personal Property Endorsement," which may be attached to a homeowners or renters policy. These two forms illustrate the extent to which the distinction between lines of insurance has become blurred—the same coverage may be issued as a separate inland marine policy or as personal property insurance.

PERSONAL PROPERTY

Personal property is property other than real property—such as furniture, linens, drapes, clothing, appliances, and all other kinds of household goods. Personal property of guests and residence employees may be covered at the insured's request.

In a standard renters policy, the insurance company will cover the personal property of any insured under the policy. Refer back to the definition of *insured*, to see that an insured is any relative of the insured

resident in the household—including persons under age 21 who are in the care of an insured.

PERSONAL WATERCRAFT

Typically excluded from liability coverage in a renters policy, **personal watercrafts** include jet skis, wet bikes or other crafts, using a water jet pump powered by an internal combustion engine as the primary source of propulsion.

Personal watercrafts do not include sailboats, air boats or other types of boats, including those powered by inboard or outboard motors. General watercrafts are also typically excluded from basic HO-4 policies unless they are owned by an insured, powered by one or more outboard motors with 50 or more total horsepower, and declared to the insurance company for proper coverage. This may result in an increase in the premium.

POLLUTANTS

Pollutants include:

- liquid fuels;
- lead or any materials containing lead;
- asbestos or any materials containing asbestos;
- radon;
- formaldehyde or any materials containing formaldehyde;

- electric fields, magnetic fields, electromagnetic fields, power frequency fields, electromagnetic radiation or any other electric or magnetic energy of any frequency;

- carbon monoxide; or

- any other irritant or contaminant, including waste, vapor, fumes, acids, alkalis, chemicals or radioactive substances.

A renters policy won't cover bodily injury or property damage arising out of contact with any pollutants.

PROPERTY DAMAGE

Property damage means injury to or destruction of tangible property and includes loss of use of the property. Note: this is broader than direct damage or destruction by a covered peril, because it also means **loss of use**. Property damage does not include loss caused by any communicable disease transmitted by any insured.

If you damage your neighbor's home, your neighbor might have to live somewhere else while the home is being repaired or rebuilt. The extra expenses for loss of use (rent, meals, transportation) could be claimed in addition to the actual damages to the home.

PUNITIVE DAMAGES

Punitive damages means damages that are awarded to punish or deter wrongful conduct, to set an example, to fine, penalize or impose a statutory penalty, and damages that are awarded for any purpose other than as compensatory damages for bodily injury or property damage.

REASONABLE REPAIRS

In the event that a loss covered by the policy causes damages in such a way as to expose property covered by the policy to further damage, the insured is allowed to make **reasonable repairs** or to take other steps to protect that property. A basic renters policy will pay up to $5,000 for these costs. This coverage does not increase the limit of liability applying to the property being repaired.

REMOVAL

Removal coverage means the coverage of property removed from the premises to protect it from a peril insured against. Coverage applies to direct loss from any cause while the property is removed. This coverage does not change the limit of insurance for the property removed, and maximum time limits typically apply. A basic renters policy will have a 30-day coverage limit for removed property.

RENTERS POLICY

A **renters policy** generally protects the possessions of tenants in a house or apartment against 17 named perils. It also provides liability coverage but doesn't

protect the actual dwelling, which should be covered under the landlord's policy. Renters who don't want to pay for liability protection can opt for a policy that covers only personal property.

The policy for co-op and condominium owners provides coverage for liability and personal property, much like HO-4. While insurance purchased by the co-op or condominium association covers much of the actual dwelling, individual owners who want coverage for improvements to their units must write them into an HO-6 policy. If you add a porch, for instance, you'll need an endorsement (an addition to your policy that expands its coverage).

REPLACEMENT COST

With regard to a loss or damage to buildings, **replacement cost** means the cost, at the time of loss, to repair or replace the damaged property with new materials of like kind and quality, without a deduction for depreciation.

With regard to a loss to personal property, replacement cost means the cost, at the time of the loss, of a new article identical to the one damaged, destroyed or stolen. When the identical article is no longer manufactured or is not available, this means the cost of a new article similar to the one damaged or destroyed and that is **of comparable quality** and usefulness, without a deduction for depreciation.

RESIDENCE

Residence premises means the dwelling, other structures and grounds, or that part of any other building

where the named insured lives, and which is identified as the residence premises in the Declarations. In the case of a two-family dwelling, the named insured must reside in at least one of the family units.

RESIDENCE EMPLOYEE

Residence employee means an employee of any insured who performs duties related to maintenance or use of the residence premises, including household or domestic services, or who performs similar duties. A residence employee can be a full-time employee, such as a live-in maid. It can also be a part-time employee, such as a cleaning lady who comes by once a week.

A caveat: Employees working in connection with a **home-based business** are not residence employees. If you hire someone to clean your basement office, that person isn't covered under your policy.

RISK

Risk is the uncertainty about loss, and transferring risk is the most important function of insurance. "Peril" is a cause of loss, or a potential cause of loss. "Hazard" is something that increases the likelihood that a loss will occur because of a peril, or something that is likely to increase the extent of a loss in the event that a loss does occur. While fire is a peril, such things as frayed electrical wires and containers of flammable liquids are hazards.

SALVAGE

In insurance terms, salvage usually refers to property taken over by an insurer to reduce its loss. In a renters

policy, **salvage** also means property having value and included in a covered loss; any value that may be realized from salvage does not diminish the amount owed by the insured under the deductible clause.

SCHEDULED PROPERTY

Scheduled property is simply property that has been inventoried and listed.

When the value of property is not listed prior to a loss, it is called **unscheduled personal property**. This makes insurance companies nervous. On the other hand, scheduled personal property refers to property specifically described in the policy. This list of described property is referred to as the **schedule**.

Typically the types of property that will be scheduled are expensive things: jewelry, watches, furs, fine arts, silverware, sports equipment, cameras, collections and home computers. They are scheduled because of their value and the need to obtain broader coverage than is provided to unscheduled property.

SEVERABILITY

Severability of insurance means that each insured person as defined in the policy has the same rights and obligations that would exist had a separate policy been issued to each. However, this severability **does not increase the limits of liability** under the policy.

SPECIFIC COVERAGE

Specific coverage provides a specific amount of insurance for specific types of property at specific

locations. An example would be a form providing a limit of insurance of $100,000 for a building and $50,000 for personal property at a single location.

SUBROGATION

Simply explained, **subrogation** means that once the insurance company has paid you for the loss you sustained, it has all the rights in or to that claim. An example: Your apartment building burns down in a fire caused by arson. Your insurance company, after paying you, has the right to sue the person responsible for the losses you suffered. However, if before any loss occurs you waive in writing all rights of recovery against any person, then the company no longer has the right of subrogation. If you don't do this, and if the company does subrogate a loss, you must sign and deliver to the company all necessary papers and cooperate with them in any reasonable way they might request to collect from the party responsible for the loss.

Interestingly, most renters policies offer arson rewards. Insurance companies will pay up to $1,000 for information leading to an arson conviction in connection with a fire loss to property covered by the policy. The insurance company will not, however, pay more than $5,000 per event regardless of the number of persons providing information.

TEMPORARY LIVING ALLOWANCE

Temporary living allowance pays for extraordinary expenses that occur when you have been displaced from your home. These expenses might include boarding a pet in a kennel, renting furniture—or paying to store furniture that survived a loss—and eating at restaurants while you're in a hotel or motel without kitchen facilities.

TERRITORIAL LIMITS

Typical of the broad coverage provided by personal inland marine coverage forms, the scheduled personal property endorsement states that the **coverage territory** for most classes of property is worldwide. However, some policies limit coverage for fine art to only within the United States and Canada.

THEFT

The word **theft** is broadly defined as the wrongful taking of property and would include **burglary**, **holdup** or **stealing**. If you discover a television set missing from your apartment and no signs that your place has been burglarized, it would be presumed that there has been a theft since the property could not have been lost or misplaced. The circumstances surrounding the loss of property must be such that there can be presumption of theft.

There's no coverage for theft of materials or supplies to be used for construction of a dwelling. Nor

is there coverage for theft of things taken by some-
one who lives with you.

UMBRELLA COVERAGE

An **umbrella policy** is designed to provide liability
insurance on an excess basis, above underlying pri-
mary insurance coverages or a self-insured retention.
(This means a deductible for losses that are not cov-
ered by primary insurance.) Generally, the scope of
the coverage is broad and the limits of coverage are
high. Insurance companies usually require substantial
amounts of underlying coverages (personal liability,
automobile liability, etc.) for known exposures be-
fore they will issue an umbrella policy.

Underlying policy or "underlying insurance" means
any policy providing the "insured" with initial or pri-
mary liability insurance covering one or more of the
types of liability listed in the deductible section of the
Declarations of a policy.

VANDALISM

Vandalism and malicious mischief include damage
done to property as a matter of spite or simply to
inflict **damage without purpose**. Vandalism as a
practical matter is the same as malicious mischief. But
these definitions can be difficult. They are covered
only under certain circumstances in a standard policy.

VICARIOUS LIABILITY

Vicarious liability is created by a minor or other
dependent for whom an insured person acts as guard-

ian. In most cases, the guardian can be held liable for the minor's behavior—even though the guardian played no direct role in the loss. Vicarious liability is a complicated insurance matter—it requires *no* direct connection.

> Renters policies will stipulate how much coverage is available for so-called statutorily imposed vicarious parental liability. In most cases, this will be the lesser of the statutorily imposed limit or $3,000, and is excess over any other valid and collectible insurance.

Example: You are sued for damage caused by your 14-year-old daughter who went joy riding. If she used your car, there is no coverage under your renters policy; if she borrowed a neighbor's car, there would be coverage.

CONCLUSION

These are a few of the basic definitions that apply to renters insurance. These definitions and others occur throughout the book to provide you with the tools necessary to understand the language involved in insuring your possessions.

WHEN DISASTER
STRIKES

As a renter, you are probably more concerned about protecting your possessions from theft and damage from perils—most notably fire—than from anything else. These are the two leading reasons tenants suffer losses, and they are what a basic renters policy covers. But there are other mishaps that you may encounter and that cannot be covered by a basic policy. **Floods** and **earthquakes** are two such perils. In this chapter, we'll look at how you can evaluate whether or not you need additional coverage for your rental unit and what kind of extra insurance is best for you.

Among the things not covered by your renters policy are earthquakes, flooding, power failure, neglect, war, nuclear hazard, intentional acts and the enforcement of building codes and similar laws.

Natural disaster losses account for a great majority of insurance claims. And there seems to be no escape from some sort of natural disaster in the U.S. The West is most vulnerable to earthquakes, the East has

its winter storms and hurricanes, the Midwest has its floods, dust storms and tornados...and the South has a mix of everything from hurricanes and floods to hail storms and windstorms.

> More than 68 million people now live in hurricane-vulnerable coastal areas of the United States, up from 52 million in 1970, a 31 percent increase over 30 years. And, some 55 percent of the U.S. population now live within 50 miles of the East or West coast.

Ninety percent of all natural disasters in this country involve flooding, according to the National Flood Insurance Program, and between 25 and 30 percent of flood insurance claims are for damage in areas designated low risk because the severity of rainstorms is growing and federal officials have not yet redrawn existing flood plain maps to reflect additional areas at risk of flooding. (Texas in particular, has been singled out as a state of higher risk of flood damage.) This may be a reason to consider flood insurance.

According to the Insurance Service Office (ISO), in 2001, insurance companies paid out $24 billion in insured property damage, the highest figure ever for **catastrophe losses**, although the number of catastrophic events was the lowest for any year since 1969. (Property losses for the World Trade Center attack were not finalized.) Tornadoes and thunderstorms in 17 states during one spring week caused $700 million in insured property losses. That's a lot of damage to wreak on the insurance industry—and people.

Getting coverage for earthquakes and flooding is pretty easy for the renter. Some experts argue that it's so easy and cheap (especially flood) that it's stupid not to have any of these extra coverages. Let's take a look.

NOAH'S ARK

When Hurricane Floyd swept through the Carolinas in late summer of 1999, a few homeowners and renters got a surprise when they returned to their homes by boat and discovered that they had lost everything. One woman returned to her rented house in Goldsboro, North Carolina, to find a total loss—her appliances, clothing, computers, stereo equipment and other personal belongings were all ruined. She didn't have to worry so much about the damage to the actual structure, but she did have to worry about the damage to her possessions. And when she notified her insurance company about the loss, she learned about **flood insurance** the hard way: a basic renters policy, which she had, didn't cover floods.

We've seen this scenario several times on the news. A bad storm hits the area, flooding occurs and people lose everything. The residents are interviewed on the evening news, and there's a recurring theme: "We didn't have renters insurance"; "We didn't have flood insurance, no one in this area does…it never floods!; and "I don't know what I'm going to do or where I'm going to stay."

Many don't think about flood insurance, especially those who don't feel threatened by this peril. Floods, however, are the **most common natural disaster**. They occur so often, most of them are not declared

disasters by the president and, therefore, victims don't get federal financial assistance. Flood insurance pays even if a disaster is not declared.

> Only 20 percent of Americans who live in flood zones actually have flood insurance, and the percentage of people who live elsewhere is substantially lower. One third of all flood claims come from outside the high-risk areas.

Although a renters policy will cover small-scale water damage from a leaky roof, bad plumbing or an over-flowing bath tub, for example, it won't cover larger-scale water damage like flooding during a serious **storm** or **tsunami**. Take note of the exact terms to your policy. You may find the following language under Property Losses We Do Not Cover:

Water Damage, meaning:

1) flood, **surface water**, waves, tidal wa-ter, tsunami, overflow of a body of water, or spray from any of these, whether or not driven by wind;

2) water below the surface of the ground, including water that exerts pressure on, or seeps or leaks through a building, side-walk, driveway, foundation, **swimming pool**, hot tub or spa, including their fil-tration and circulation systems, or other structures;

3) **water that backs up** through sewers or drains originating outside of the residence premises' plumbing system; or

4) water that backs up, overflows or discharges, for any reason, from within a sump pump, sump pump well or any other system designed to remove subsurface water that is drained from the foundation area.

Direct loss by fire, explosion or theft resulting from water damage is covered, however. Insurance for sewer backup can be covered in a separate, inexpensive policy rider. But floods in general are a special peril for which a **special type of insurance** must be purchased.

If you live on the first floor, in a basement or on the ground or garden level in an area that could be prone to flooding, then you need flood insurance. Most commercial insurance companies simply don't write flood insurance; many won't write any insurance for homes or renters in flood plains. There is, however, a way to obtain some coverage.

If you live near a 100-year flood zone, your home has a 1 percent chance each year of being flooded. One percent seems low, but if you knew that you had a 1 percent chance of winning the lottery, you'd probably buy a few tickets once in a short while.

So, how do you get flood coverage? The easiest way is to go through the **National Flood Insurance Pro-**

gram (NFIP), which is part of the Federal Emergency Management Agency. The NFIP is the primary provider of flood insurance in this country. You can buy NFIP flood insurance from your private insurance company or agent; thus, coverage is financially backed by the U.S. government through this special program. And, since renters only have to be concerned about their possessions, all you need is **contents only** flood coverage, which is relatively cheap. Up to $100,000 contents coverage is available for renters, but most can probably make do with $20,000-30,000 in contents coverage. The only catch: You must apply for flood coverage at least **30 days in advance**. You cannot watch the weather report and then expect to have a policy effective at midnight.

Everyone lives in a flood zone. It doesn't matter whether your flood risk is high, medium or low, you can buy flood insurance as long as your community participates in the National Flood Insurance Program. Remember: almost 25 percent of all flood insurance claims come from low- to moderate-risk areas. NFIP statistics show that over one in four claims are paid to business owners, homeowners and renters located outside the floodplains!

You are probably more at risk for flooding than you think. You may not live in Houston or near the flood plains of the Mississippi, but severe snow, overflowing rivers, heavy rains (El Niño), levy or dam failures can cause flooding. If your community does not participate in the NFIP, ask your insurance company or agent what you can do to acquire coverage. Your in-

surance company or agent can best help you **assess your risk** for flood and whether or not it's wise for you to purchase a policy.

Beware of certain **contents that are not insurable under a flood policy**:

- animals and livestock;

- licensed vehicles;

- jewelry, artwork, furs and similar items valued at more than $250;

- money or valuable papers; and

- items in a structure that does not qualify as an "insurable building" such as garden tools stored in an open carport.

If you need these items covered, ask your insurance company or agent. There may be supplemental insurance available to you.

Under the federal Hazard Mitigation Grant Program, states receive funds to buy properties in flood-prone areas. Data from the Federal Insurance Administration show more people are purchasing flood insurance. As of December 2000, there were 4.4 million policies in force, or $568 billion in coverage.

For more information, contact the National Flood Insurance Program at 1.800.427.9662 or the Federal Emergency Management Agency at 1.800.427.4661. Information is online at *www.fema.gov/nfip.cost.htm*.

WIND COVERAGE

Renters policies differ from place to place. And, as with flood insurance, the kinds of policies available to you depend on where you live and what kind of weather passes through your community. Another item to consider when looking at your policy is whether or not **wind** is covered. Many policies automatically include coverage for damages caused by a **windstorm or hail**:

> This peril does not include loss to the property contained in a building cause by rain, snow, sleet, sand or dust unless the direct force of wind or hail damages the building causing an opening in a roof or wall and the rain, snow, sleep, sand or dust enters through this opening.

> This peril includes loss to watercraft and their trailers, furnishings, equipment, and outboard motors, only while inside a building with: continuous walls on all sides extending from ground level to the roof; doors and windows in the walls at various locations; and a continuous roof sheltering all areas within the wall perimeter.

However, if you live in a high-risk zone for wind and hail (i.e., hurricane zones), you may have to obtain wind and hail coverage through a rider and accept a higher premium. Basic policies written for people who live in these zones may not find wind and hail on their policy. Refer to your policy or ask your agent for more information.

Since Hurricane Andrew, Florida has created various insurance mechanisms to help the state better deal with the risk of hurricanes, including the Florida Hurricane Catastrophe Fund.

Hurricanes can be ugly perils because they mix **wind and water**. The government has had to encourage insurers to stay in the marketplace in some areas (like the Florida coast) to help deal with these catastrophes. The **Florida Hurricane Catastrophe Fund** was set up by the state in 1993 after reinsurance became more difficult and expensive to obtain following Hurricane Andrew. Premiums are based on exposure to loss. Insurers can purchase coverage at various levels of reimbursement—45 percent, 75 percent and 90 percent of annual hurricane losses. In addition to premiums, insurers buying coverage from the Fund pay a 6 percent assessment on all policies sold in the state—except workers' compensation—which can be passed on directly to consumers. Once the Fund reaches $22 billion, when it is fully funded for a second season, the cap will increase by 50 percent of the growth in its exposure to losses. The state can issue $7.36 billion in bonds after a hurricane.

After Hurricane Andrew and with computer-based models of storms, coastal development patterns and increasing values showing how vulnerable insurers were to large weather-related losses, insurers had difficulty finding the reinsurance coverage they needed to protect their own bottom line. Many

> couldn't obtain coverage unless they agreed to greatly reduce their potential maximum losses from such events through higher deductibles.

In March 2002 the Florida legislature approved a plan to merge two organizations, the Florida Residential Joint Underwriting Association and the **Florida Windstorm Association** that covers property in specifically designated areas most vulnerable to storm damage, into a single entity. The new pool is called the **Citizen's Property Insurance Corporation** (CPIC), and is run by a seven-member board of directors appointed by the state treasurer. The insurance industry will set up an advisory council to work with the board.

These types of state-run set-ups are typical in high-risk areas. They allow the industry to spread the risk associated with predictable catastrophes. Another examples can be found in Texas, where, along with windstorms, hail storms can also cause catastrophic losses. There, the insurance department has set up a Market Assistance Plan (MAP) for 427 zip codes where insurance may not be readily available, including hail-prone regions. MAPs are programs designed to put people having difficulty obtaining insurance in touch with insurers willing to accept more business. Note, however, that as a renter you are more likely to find contents-only coverage more easily than if you were a homeowner.

Insurers in 17 catastrophe-vulnerable states may now use percentage deductibles on insurance policies, as opposed to a dollar deductible, to limit their exposure to catastrophic losses from natural disasters.

EARTHQUAKE COVERAGE

There's been a buzz about "The Big One" hitting California for years now. Whether you're worried about the Hayward Fault or living on the San Andreas, the numbers point to a high probability of there being a major quake within the next few decades—despite the enormity of geological time. For example, according to the U.S. Geological Survey, there is a **70 percent probability** that one or more damaging earthquakes of magnitude 6.7 or larger will strike the San Francisco Bay area during the next 30 years. This would be equivalent to the 1994 Northridge earthquake that killed 57 people and caused $20 billion in damage.

Although an earthquake can hit anywhere at any time, the residents of the Western states are usually more concerned about seeking earthquake coverage that those who live in other parts of the country. That doesn't mean that you cannot find coverage if you live in Maine or Kentucky. Statistics show that since 1900, earthquakes have occurred in 39 states and have caused damage in all 50. About 5,000 quakes can be felt each year, with some 400 capable of causing damage to the interior of buildings and 20 capable of causing structural damage. A major earthquake (8.2

on the Richter scale) in San Francisco could cause as much as $84 billion in damage. However, a major earthquake on the East Coast, though more unlikely, could cause much greater damage. Because earthquakes in the eastern part of the country tend to be **thrust-fault quakes**, which produce an up-and-down motion rather than the horizontal side-to-side common in California, damage could be 10 times greater, according to seismic experts. The degree of damage also depends on other variables such as the structure of the building and soil conditions.

No matter where you live, renters insurance does not automatically cover losses caused by an earthquake—but earthquake coverage for the residence, other structures and personal property may be attached by **endorsement**.

Several earthquake-prone states—most notably California—require any insurance company that writes homeowners coverage to also write earthquake coverage. This doesn't mean these companies have to publicize earthquake coverage. Most stay quiet about it. But they have to give you information, if you ask.

Specifically, the California law mandating earthquake insurance says:

> No policy of residential property insurance may be issued or delivered or, with respect to policies in effect on the effective date of this chapter, initially renewed in this state by any insurer unless the named insured is of-

fered coverage for loss or damage caused
by the peril of earthquake as provided in this
chapter. That coverage may be provided in
the policy of residential property insurance
itself, either by specific policy provision or
endorsement, or in a separate policy or cer-
tificate of insurance that specifically provides
coverage for loss or damage caused by the
peril of earthquake alone or in combination
with other perils.

When earthquake coverage is purchased, an **additional
charge** is made for the coverage. This can be expen-
sive if you're seeking coverage for the structure of
your home, but renters need only concern themselves
with their possessions. Thus, coverage for a renter is
not so bad—less than $40 a year for personal prop-
erty coverage of $25,000 with a 15 percent deduct-
ible and additional living expenses. This is a bargain if
you're worried about earthquakes.

The type of construction of the structure is a signifi-
cant factor in earthquake rates. Different rates apply
to frame buildings (wood, or stucco-covered wood
structures) and to those classified as masonry (brick,
stone, adobe or concrete block).

> For earthquake coverage, masonry rates are usually
> higher than frame rates. For ordinary property cov-
> erages, the reverse is true—masonry rates are lower
> than frame rates. This situation exists because of
> the nature of the exposure: wooden buildings are
> more vulnerable to fire than stone or brick buildings
> are; but stone or brick buildings are more vulner-
> able to earthquakes than wooden buildings are.

The exact cost of coverage may depend on where you live. Factors that become a part of the equation include:

➡ Location: where you are;

➡ Hazards: where the faults are, how big an earthquake can be and how shaky the ground is underneath you (sand? bedrock?); and

➡ Vulnerability: your **building's risk factors**, such as weaknesses it has from building codes and local construction practices that could lead to damage in the next quake.

The Northridge quake changed a lot about how coverage works in California. Following that quake, insurance companies refused to sell fire and earthquake insurance after suffering terrible losses. It was the **second most costly natural disaster** in the history of the U.S., causing $15.3 billion in insured losses, according to the Institute for Business and Home Safety. The quake caused more than 50 deaths, 12,000 injuries and destroyed some 8,000 homes. More than 114,000 buildings were damaged and some 430,000 claims were filed.

Because California law mandates that any company offering fire insurance must also offer earthquake insurance, the companies stopped offering fire policies. This created a crisis among California insurance consumers so the **California Earthquake Authority (CEA)** formed to take the losses that otherwise would have gone to the private insurers. That's when the private insurance market started selling fire insurance again and consumers could purchase earthquake

through the CEA. When some private insurers started selling privately funded earthquake insurance, the CEA suffered a loss of premiums, and were forced to accept only the high-risk properties. Whether this setup eventually bankrupts the CEA is yet to be determined. You as a renter have a choice of either choosing a privately funded earthquake policy or a CEA policy.

If you talk to your insurance company, it will tell you what kind of setup is usual to its customers. The CEA policies are called **mini-policies** because they offer so little coverage. Privately funded policies generally match the CEA policies and usually offer more comprehensive policies. And their prices are often lower than CEA policies. Another option is to obtain a **supplemental, "wraparound,"** policy for those who already have mini-policies and still want more coverage. If your insurance company only offers CEA policies and you'd prefer a private one, you can do some research and find a company that will write a policy for you. Examples of these companies that offer more comprehensive coverage include:

- AMICA Mutual;
- Calfarm Insurance Company;
- Chubb Group;
- Clarendon Group;
- Five Star Insurance Company;
- Geovera Insurance Company;
- The Hartford; and
- Pacific Select.

> Deciding whether or not to have earthquake insur-
> ance is up to you. Generally it's a cheap addition to
> your basic renters policy because you are covering
> only your possessions. If you live in an area prone to
> earthquakes and you know that your building is
> vulnerable to damage, you might want to consider
> this extra coverage.

Earthquakes are listed under **Earth Movement** in your basic policy, where it's indicated that the policy does not cover this peril (an earthquake insurance policy will be separate from the basic form). Other things considered earth movements, besides earthquakes include:

> landslides, mudflows, mudslides, subsidence, volcanic eruptions or lava flow, erosion or movement resulting from improper compaction, site selection or any other external forces.

Earth movement in general means *sinking, rising, shifting, expanding or contracting of earth, all whether combined with water or not.*

A final note about earthquakes: If the earth movement is a **direct result** from fire, explosion or theft, then your basic policy should cover the loss. So, if an earthquake breaks gas lines, which in turn starts a fire...and your building goes up in flames, then your basic renters policy will cover you.

FIRE!

A renters policy automatically covers fire. It's the number one peril to protect yourself against as a renter.

Nowadays homeowners policies include fire coverage, but that wasn't always the case. It used to be that fire insurance was something you had to obtain separately—especially if you were a homeowner and wanted more complete coverage. As a renter, a basic policy will probably suffice for covering you. Just don't go starting fires in your unit in the hopes of collecting insurance and replacing your possessions with new things. This not only voids any insurance contract, but it can lead to trouble.

> In July 1999, a young man and his mother took out a renters policy on the apartment where they lived. Soon afterwards, they torched the building to collect $20,000. Three firefighters died as a result of the blaze. The young man is in prison serving life.

A FINAL NOTE ABOUT DISASTERS

Over the 20-year period, 1981 to 2000, tornado losses made up 33.9 percent of total catastrophe losses, followed by hurricanes (31.8 percent), earthquakes (11.8 percent), winter storms (13.0 percent) and wind/hail/flood (5.1 percent).

The emphasis in the insurance industry is on measures that can prevent or reduce damage caused by natural disasters. For example, the insurance departments in Florida, Oklahoma and Texas are developing plans to better respond to disasters by improving coordination at all levels of government, identifying the ad-

justers of major insurers in each county, providing adjusters with access to disaster sites and creating mediation programs to help resolve claim disputes. In addition, insurers have formed a new organization, the **Insurance Building Code Coalition**, to press for stronger, standardized building codes nationwide and proper enforcement. But there is very little uniformity. Some states have no statewide code, while some communities within those states have their own codes. And some codes only apply to specific types of structures.

It'll take time and an enormous amount of planning and money before the state of the insurance industry can match the strength of natural disasters. In the past few years, insurers have sought to make people who live in areas vulnerable to natural disasters pay more of their fair share of the cost of disasters by creating higher deductibles for natural disaster damage.

The insurance industry tracks catastrophes to monitor claim costs and because some reinsurance contracts are linked to catastrophes. The industry's definition of a catastrophe is now $25 million in insured damage. This figure has changed over the years with inflation and the increase in development of areas subject to natural disasters.

You don't want to have to rely upon federal disaster assistance to help you recover from a catastrophe. In most cases, the president won't declare an area a "national disaster" area, so you'll be on your own. Any

federal relief will be limited anyhow, so having a policy to supplement the cost of recovery is key.

Your best source of information regarding state-run programs and available insurance policies is to contact your local insurance agent or the **Insurance Information Institute** at 110 William Street, New York, NY 10038 (212.346.5500). For the Web site, go to *www.iii.org*.

CONCLUSION

This chapter explored the possibilities that are available for renters in high-risk areas for floods and earthquakes and other disasters. Because renters don't have to fret over the physical damage done to a building after a violent storm, earthquake, hurricane, windstorm, etc., finding the additional coverage for your possessions is easier than for property owners. It's also pretty cheap. A basic renters policy will cover you for most of the perils you may encounter in life, but if you live in a flood zone or on an active faultline, you may want to think about paying a little more in premiums for additional coverage. If your insurance company refuses to cover you for these extra perils under a broad coverage form—you can acquire additional coverage elsewhere or from one of the federally-funded programs.

The most vital thing you can get out of having additional coverage in the form of flood and/or earthquake insurance is **peace of mind**. With that point in mind, let's move on to our next chapter where we'll look at how you get renters coverage in the first place and how you make a claim when something goes wrong.

CHAPTER

7

HOW TO GET COVERAGE AND HOW TO MAKE A CLAIM

Getting renters insurance is relatively easy as compared to filing a claim and getting your carrier to come to your rescue. But it shouldn't be too hard. In this chapter we'll start out by talking about how to purchase insurance and then we'll finish by describing the process of claims-filing.

SEARCHING FOR COVERAGE

You shouldn't have to go far when looking for an insurance company to write a policy for you. Finding an insurance company to cover you is as easy as picking up the phone or logging onto the Internet. If you have **friends or neighbors** who have renters policies, ask them for the name of their carrier. Some insurance companies will not write any renters policies because they just don't offer that kind of service, but there are plenty out there to choose from that do.

> If you already have a Personal Auto Policy, start by calling your auto insurer to see if the company offers renters insurance. Having two or more policies

from the same insurance company usually means discounts. A 10 percent discount, for example, could translate to a few extra bucks in your wallet for other things.

Although many Web sites make it sound like buying insurance is as easy as entering a credit card number and double-clicking your way to coverage, this is not the best method. The definition for a policy sold online is broad and very few policies are **sold online** without a conversation taking place between the insurer and the buyer over the phone. Most are sold with a combination of online and off-line interaction—if there's any Internet action involved. But by looking at some of the online applications, you can become familiar with the kinds of material you'll need to provide. These include:

- name and address (including state);
- square footage of your unit;
- deadbolts on doors/windows?;
- location(s) of fire extinguishers;
- locations of nearest fire station;
- sprinkler system?;
- fire and smoke alarms;
- year of building's construction;
- date you moved in;
- number of units;
- number of stories (and your level);

- construction type (frame, masonry, masonry veneer, superior);

- roof type (tile, slate, metal, woodshake, composite material); and

- roof updates.

In addition to these things, you may have to include an itemized list of things and their value for the following:

➡ jewelry and furs;

➡ business personal property;

➡ home computers;

➡ silverware and goldware; and

➡ other items that may require you to obtain additional coverage.

You should **take inventory** of your possessions before calling the insurance company. Having an idea of how much you need to insure will make answering your agent's questions easier. You may also be asked about the storage of your car, whether it's on the street or in a gated parking lot, whether you have pets and how the building is maintained. If there's an on-site manager, tell you agent.

In many cases, an insurance company will already know about the risk it's taking on by selling you a policy. It will have access to information regarding the area where you live, the crime rate, the response time to emergencies, the number of miles to the nearest fire station and various demographical data. If your insurance company has written contracts for other tenants in the same building, it'll be easy to reach an accurate estimate for proper insurance.

Don't neglect to mention roommates, live-ins, etc., when buying insurance. Sometimes you add names to your policy, but in many cases (especially with regard to contents coverage) the people with whom you live will have to obtain their own policies. If your personal property is jointly owned or considered shared property, a renters policy may be written with both partners listed as named insured. If the personal property is not jointly owned and not shared, separate policies are typical.

MAKING A CLAIM

All the effort you put into purchasing the right kind of insurance coverage comes into play when you have to **make a claim** on your policy.

As a policyholder, instead of sitting back and waiting for a disaster to happen, you should familiarize yourself with the steps that go into the claims-making process to avoid costly and time consuming mistakes.

Billions of dollars are paid out each year to policyholders for claims resulting from losses suffered during fires, hurricanes, tornadoes, robberies, auto accidents, dog bites, falls, etc.

It is important to remember that filing a claim is a process, and knowing you rights throughout this process can be pivotal to getting your claim paid.

Your insurance company at any time and for any reason has the right to investigate any claim that you make. But if you present your circumstances effec-

tively, your insurance company may allow your claim, which can save you a crucial amount in expenses.

The process of making a claim and getting it paid is the **adjustment process**. To make this process work for you, it is first important to know what your duties are when a loss occurs.

YOUR DUTIES AFTER A LOSS

If you have an insurable loss, it is helpful to know the **duties required of you** as a policy owner. Generally, your policy states that you are required to:

- provide the insurance company with immediate notice of a loss;

- cooperate in the investigation, settlement or defense of any claim or suit;

- notify law enforcement in case of loss by theft, and a credit card fund transfer card company in case of loss to credit card or fund transfer card;

- protect your property from any further damage or make necessary repairs to protect the property;

- submit a complete and detailed inventory of all damaged and undamaged property, quantities, costs, ACV and the amount of loss claimed;

- forward any legal papers received (such as a summons), to the company immediately; and

- submit a signed proof of loss (within 60 days of the loss) stating the time and

origin of loss, interest of all parties in-
volved, other insurance, value of each
item, and any other information which
the policy requires.

Your insurance company may also request that you
submit appropriate records, exhibit the remains of
the damaged property, or submit to examinations
under oath.

If you don't comply with your duties after a loss oc-
curs, your insurance company will not be obligated
to pay your loss.

Contacting your insurer and the police after you
have suffered a loss is an important part of the
claims process and fairly simple. But in addition to
complying with your duties after a loss—you want
to carry them out in a way that will assure you the
maximum timely settlement. And knowing how your
insurance company looks at a claim will help you
with this process.

You have 20 days to provide **notice of a claim** to
your insurer or agent. If you can't comply with this
time frame after an accidental injury, you must send
notice of a claim as soon as reasonably possible.

Don't throw anything out after a loss has occurred,
an adjuster may want to see all the damaged items
before approving your claim.

If a loss covered under your policy causes damage in
such a way as to expose your property to any further

damage, you have an **obligation to make reasonable repairs** or to take other steps to protect the property.

> For example: If a windstorm blows away a portion of your roof, the policy would pay for—and actually require—temporary repairs to the roof to avoid further damage to the interior of the structure. If you don't make the reasonable repairs, the policy won't cover any further damage.

A standard policy allows you to move your property from a premises threatened by a covered peril to a safe place for a period of 30 days. Coverage would apply to the property during the move and while at the other location for loss from any cause—which expands your coverage considerably.

However, if you don't take the necessary precautions, your insurance company may interpret that as a failure to reasonably protect your property from damage.

If your insurer is looking for a way to get out of paying a claim, it may try to expand a dispute over prevention into a dispute over **policy owner neglect**—a specifically excluded coverage.

Disputes between you and your insurer generally center around coverage issues—specifically whether or not a particular loss is covered under your policy. Because insurance companies try to protect themselves from the negative financial impact of paying out large

claims, they often deny coverage by pointing at some fundamental issue—usually something not at all related to the specifics of the claim. This is why it is so important to know your duties as a policyholder after a loss occurs.

MISREPRESENTATION

If any party to an insurance contract misstates a matter of fact, a misrepresentation has occurred. This can be **grounds for nullification** of the policy—or damages in excess of the policy limits.

An applicant who has been cancelled by previous carriers for excessive claims and does not show this on the application is making a material misrepresentation, since the carrier would probably not issue a policy if this information was known.

The case of *Wagnon v. State Farm Fire and Gas Company* illustrates this point well. If you don't follow the rules stipulated in your policy, you may wind up paying for the loss out of your own pocket, as did this family in a 1998 Oklahoma **case of misrepresentation**. Here, however, it was less about following the rules of making a claim and more about breaking the rules when filing a **false claim**.

In January of 1992, Charles and Loralee Wagnon purchased a renters policy from State Farm, insuring their property against fire and other perils, including theft. The policy contained a **provision voiding coverage** if any insured "intentionally concealed or misrepresented any material fact or circumstances to this insurance, whether before or after a loss."

On April 4, 1992, the Wagnons' home was burglarized and six days later they filed a proof of loss with State Farm, claiming the loss of personal property in the amount of $21,176.84. This claim included the loss of tools (a "set" of 527 individual pieces) worth approximately $4,300. Although Mr. Wagnon indicated he had acquired many of these tools four years earlier, he did not submit any receipts, cancelled checks or pictures to support his claim of ownership.

During State Farm's interview with Mr. Wagnon, he stated that "a lot of em my dad and I had when I was living at home and ah I just collect em, you know, like that and then on I just kept gradually getting um." During a statement under oath, Mr. Wagnon said that most of the tools had been given to him by his father, but that he **couldn't remember exactly** which ones he'd received from his dad and which ones he had purchased himself. Toward the end of one examination, Mr. Wagnon testified that he did not know his father's address and he refused to give State Farm his father's phone number.

Failure to cooperate with an investigation—including failing to give material information—is grounds for claim denial.

His father eventually surfaced. In August, Olen Wagnon wrote a statement that said he'd given his son "some tools" but he denied giving his son the vast majority of the items Charles Wagnon had listed in his set and that were to have come from his dad. Charles Wagnon's response to this:

I was going to, after we got done with going over all them tools, say the reason that I told you that my father gave them to me just the simple fact is that I didn't want to complicate, I couldn't remember exactly where I got them from. I went to, like, flea markets, garage sales, and acquired the tools there, but I can't tell you where I got them from exactly.

So, Mr. Wagnon was **caught having lied** during earlier testimony. But this was just the icing on a big cake. By the time this case went to court, State Farm had amassed some serious evidence. And many things didn't add up. First, the Wagnons' policy was new and their loss was large. They were in their early twenties with two children, working at low-income jobs with inconsistent job histories. They were largely **unable to produce any receipts or proof** that they owned the allegedly stolen items, saying that such receipts had been taken in the burglary. The Wagnons also changed the source of the items between their first proof of loss.

According to State Farm, there was a "considerabl[e]" discrepancy between the dollar amounts listed by the insureds for firearms, tools, and stereo equipment in their insurance application and the amounts claimed as stolen three months later.

During State Farm's visit to the residence, the agent noticed a few things:

- high priority items (i.e., stereo and TV) were not taken;

- heavier, bulkier items such as a file cabinet containing the receipts and some jewelry, were claimed to have been stolen; and

- there was no electrical outlet near where the air compressor was allegedly used.

The story gets even better. In August 1992, Mrs. Wagnon's former brother-in-law notified State Farm that the Wagnons' claim was fraudulent. He also said that the Wagnons planned to set fire to their home, and, in fact, the Wagnons' home burned in December of 1992. State Farm also knew that Mrs. Wagnon had two **juvenile felony convictions** for obtaining merchandise by bogus check, and one misdemeanor conviction for larceny of merchandise from a retailer.

It's no surprise that this kind of evidence led State Farm to deny the claim, which it did in December of 1992, on the ground that both Mr. and Mrs. Wagnon misrepresented certain facts regarding the items stolen and the existence of lawsuits against Mrs. Wagnon.

The district court ruled in favor of the Wagnons, concluding that although Mr. Wagnon misrepresented the source of the tools to State Farm, his misstatements did not vitiate coverage under the policy. This may have come to a surprise to State Farm, but things changed on appeal. The appeals court said:

> Mr. Wagnon's misstatements regarding the source of the tools, and his concealment of the means to verify his statements, were material as a matter of law. State Farm had ev-

ery right to investigate whether plaintiffs truly owned the items they claimed were stolen, and questions regarding the source of the items were germane and relevant to this ownership inquiry.

It wasn't hard for the appeals court to find **intentional misrepresentation**. It wrote, "no reasonable factfinder could question whether Mr. Wagnon's misrepresentations were made intentionally with the intent to deceive State Farm." It was evident through the case that Mr. Wagnon lied, even conceding to his own lying (he admitted that his statements were made knowing that they were false). Mr. Wagnon also admitted at trial that he concealed his father's phone number, in part, to prevent State Farm from contacting him and learning the truth about the tools.

According to the court, so long as Mr. Wagnon's misrepresentations were made knowingly and deliberately, the intent to deceive the insurer will be implied.

The appeals court reversed the district court's ruling, concluding that State Farm had reason to declare the policy void. If the Wagnons had indeed lost a pricy set of tools, then they'd have to pay to replace them.

LIMIT OF LIABILITY

When a covered loss occurs, your insurer has a **limit of liability**, or legal responsibility to honor their contractual agreement to pay damages to you or to a third party on your behalf.

The limit of liability is simply the amount of coverage, the maximum amount of insurance or upper limit that the insurance company is legally obligated to pay if a covered loss occurs.

If a covered loss occurs for less than the limit of liability, your insurance company will pay the amount of the loss (minus any deductible that may apply). If the amount of the covered loss is more than the limit of liability, your insurance company will pay the limit of its coverage and you will be responsible for paying the additional costs.

PROOF OF LOSS

If your insurer fails to provide you with claims forms within 15 days after receiving your notice of claims, you may comply with the policy's **proof of loss** requirements by writing to your insurance company and detailing the occurrence, and the character and extent of the loss.

It is important to document your loss as thoroughly as possible. After contacting your insurer, they will usually send you a proof of loss form to complete. In some cases, they may **send an adjuster** out to your house to go over the form with you. If you have an inventory ahead of time, filling out this form will be a lot easier.

A proof of loss form generally tends to be uniform with different insurance companies. If you're not sure what should go into this report, here are a few guidelines on what should be included:

- the time and cause of the loss;

- specifications of damage and detailed repair estimates;

- an inventory of damaged personal property;

- any other insurance which may apply to the loss;

- the interest of you and all other parties in the property involved (such as mortgage companies, lien holders, etc.);

- changes in the title or occupancy of the property during the policy term;

- if possible, receipts for any property that has been damaged;

- evidence or affidavit that supports a claim under the Credit Card, Fund Transfer Card, Forgery and Counterfeit Money coverage, stating the amount and cause of loss.

Losses will be adjusted and paid to you—unless the policy indicates that payment should be made to someone else (such as a mortgage holder). An adjuster may want to see all damaged items, so avoid throwing out anything after a loss has occurred.

It's a good idea to make a list of everything that's been stolen or damaged as soon as possible. Include a description of each item, the date of purchase, and what it would cost to replace today (if you have replacement-cost coverage). Any receipts,

> bills, photographs or serial numbers from high-
> ticket purchases can also be helpful in establishing
> the value of your losses.

You don't have to wait for a major loss to occur to do this. You should keep a list that includes this information in a safe place at all times.

For a useful example of a property inventory chart turn to Chapter 3 of this book.

ABANDONMENT

An **abandonment clause** prohibits you from abandoning your property to your insurer in order to claim a total loss. Although the company may choose to acquire the damaged property that can be sold for **salvage** and may choose to pay a total loss, you cannot insist that your insurance company take possession of any property.

For example: You have a loss due to a fire in the storage shed in your backyard. Most of its contents are damaged, but there are some that are not. You cannot tell your insurance company, "I had $6,000 worth of stuff in the shed. Pay me $6,000 and the stuff is yours." Your insurer will usually not accept this kind of a proposition because it has to make arrangements for hauling, repair and sale of the salvageable property and it usually does not care to do this.

If you collected on a property loss due to a theft and the property is recovered two months later, you have

the option to take the property and pay your insurer the original amount paid for the loss. Or you can keep the money and let the company keep the property.

Despite the specified amount of insurance, your **insurable interest** may limit the amount paid on a claim. Other parties may have an insurable interest in your property as an owner, mortgage holder, vendor, lien holder, stockholder, joint owner, bailee or lease holder.

Once an insurance company has paid you for the loss you sustained, it acquires your rights in the claim. This transfer is called **subrogation**.

> If your neighbor loses control of his car and crashes into your garage, your insurance company, after paying you, now has a right to sue your neighbor to collect from him the amount it paid to you. Once you receive payment, you "subrogate," or pass on, your rights in the claim to the insurance company.

If you become **bankrupt or insolvent**, the insurance company remains obliged to provide coverage and to respond to the terms and conditions of the policy.

Your renters policy may include the following language: "With respect to the personal liability coverage, this policy is excess over any other valid and collectible insurance."

The practical application of this clause varies, depending on the other insurance. Duplication of coverage of-

ten ends up with both insurance companies contributing to payment of a loss.

The other insurance clause doesn't apply to so-called true excess liability insurance—like standard umbrella liability policies. Umbrella policies remain a secondary form of insurance to a homeowners or renters policy.

Once your insurer has paid you for the loss you sustained, it has the rights in the claim.

UPDATE COVERAGE

Millions of insureds often slip up on their insurance coverage—later to find out that the new $5,500 computer that they brought home isn't covered when it's stolen three weeks later. Don't wait till you get home from the store to purchase coverage. Chances are, you'll know ahead of time that you are going to make a purchase of that size. Insure it first—then bring it home.

Most people know that they need to insure their possessions, but they often get careless when it comes down to purchasing coverage. They often leave out items or don't purchase the right amount of coverage. One way too help avoid this is to **videotape everything you own**. Appraisers are now suggesting that you simply walk through your residence with a video camera and tape everything. Film the paintings on your walls, your jewelry box and even your closet. Most people remember to insure their jewelry and their mink coat but forget to appraise their wardrobe, which could be as much as $75,000.

If you have a videotape, photos or the actual appraisal written down—be sure to make a hard copy of it and keep it off the insured premises (a safety deposit box is a good place).

People often go through all the trouble of paying for an appraisal, taking photos or videotaping only to leave this evidence on the insured premises. This won't help if your place burns down.

LOSS PAYABLE CLAUSE

The **loss payable clause** of a standard policy, states that if you provide the proof of loss and other information—and the amount of loss has been agreed upon—your insurer will pay for the loss **within 60 days** (laws may vary from state to state).

> Your duty as a policyholder is to assist the insurance company in making settlements or making claims against other parties who might be responsible for the loss, and to be available for court trials, hearings or suits, and give evidence as required.

If you don't provide proof of loss information, or in some way alter the information, you may find yourself shelling money out of your own pocket for repairs or even replacements.

However, there is a **time limit** on certain defenses. This provision limits the period in which your insurer may seek to deny coverage by questioning the truth-

fulness of your statements on an insurance application. Depending on the state you live in this law will vary from two to three years.

After your policy has been in effect for the specified number of years, your insurer can no longer contest coverage on the basis of your omissions or misrepresentations unless your insurance company can prove that they were made with the intent to defraud. This provision is also called the **incontestable provision**.

If you have provided the necessary proof of loss forms and the actual amount of the loss has been agreed upon by both you and your insurer, your insurance company will have 60 days to pay out your claim. Even if you are angry because your property has been stolen, you can't change the black and white of the policy.

From time to time, policy owners bring suits against their insurance companies when they are dissatisfied with claim adjustments. Before this can be done, you must comply with the **policy provisions** concerning the reporting of the loss, cooperating with the company in settling the loss, etc.—and any suit must be brought **within one year** after the loss.

Be sure to update your insurance coverage. Many people forget to update their coverage beyond the automatic inflation of most policies.

> Whenever language in an insurance policy is am-
> biguous, any dispute over coverage is ruled in fa-
> vor of the policy owner. The insurance company has
> its opportunity to set terms in the drafting of the
> policy.

PROPERTY VALUATION

Property losses under the basic renters form are gen-
erally settled on an **actual cash value** basis. All forms
support the principle of **indemnity**, which—in this
context—means recovery may not exceed the small-
est of four amounts:

- the ACV of the property at the time of
 loss;

- the policy limit for the coverage;

- the amount necessary to repair or replace
 the property;

- the amount reflecting the insured's inter-
 est in the property at the time of the loss.

When a loss is adjusted on an actual cash value basis, a
deduction is made by the insurance company for the
depreciation of the property. The term depreciation
refers to the gradual reduction in the value of prop-
erty as a result of time and use.

Because the cost of a policy that covers you for total
replacement of lost property is not that much more
expensive that a policy that pays only cash value (**ac-
tual value**, or cost minus depreciation), it's wise to
choose the replacement cost policy—sometimes called
full renters value.

For example, if you buy a luxury couch for $3,000 and five years later a fire destroys it, you'd rather be covered for the cost of replacing that couch than for receiving the cash value of that five-year old couch. The latter would be so much smaller in amount that you wouldn't be able to find the same type of couch again for the money.

Some types of property are not eligible for replacement cost settlement. These include: antiques, fine arts, paintings and similar articles of rarity or antiquity that cannot be replaced; memorabilia, souvenirs, collectors items and similar articles whose age or history contribute to their value; personal property not maintained in good or workable condition; personal property that is outdated or obsolete and is stored or not being used; personal property not owned by an insured; and motorized land vehicles or earth moving or excavating equipment used to service the property.

Despite this long list of things you cannot replace at full renters value, you can pay an extra premium to get awnings, carpeting, domestic appliances, outdoor antennas and outdoor equipment covered at replacement cost.

If after meeting with an adjuster, you and your insurance company fail to agree on the value of your loss, your method of appeal is outlined by the standard renters form. The policy states:

If you and we fail to agree on the amount of loss, either may demand an appraisal of the loss. In this event, each party will choose a competent appraiser within 20 days after receiving a request from the other. The two appraisers will choose an umpire. If they cannot agree upon an umpire within 15 days, you or we may request that the choice be made by a judge of a court of record in the state where the [house] is located. The appraisers will separately set the amount of loss. If the appraisers submit a written report of an agreement to us, the amount agreed upon will be the amount of the loss. If they fail to agree, they will submit their differences to the umpire. A decision agreed to by any two will set the amount of the loss.

When valuing your property, you may want to contact an appraiser. You should find an appraiser who belongs to the American Society of Appraisers in Washington D.C. or the Appraisers Association of America in New York. Both groups can provide you with a directory of members:

American Society of Appraisers, 555 Herndon Parkway, Suite 125, Herndon, VA 20170; (703) 478-2228, fax: (703) 742-8471; e-mail: asainfo@appraisers.org; Web site: *www.appraisers.org.*

Appraisers Association of America, 386 Park Avenue, Suite 2000, New York, N.Y. 10016; (212) 889-5404, fax: (212) 889-5503; e-mail: aaa1@rcn.com; Web site: *www.appraisersassoc.org.*

You can also get recommendations on appraisers by calling the Appraisal Institute in Chicago, IL (312) 335-

4100. They are located at 550 W. Van Buren Street, Suite 1000, Chicago, IL 60607; Web site: *www.appraisalinstitute.org.*

To find an ASA-accredited appraiser near you, call the referral line at 1 (800) ASA-VALU or log onto their Web site listed above.

STRENGTHENING CLAIMS

Be sure to read your policy. This is very important. If you know what kind of coverage you have, you are more than likely to receive all that you are entitled to. The following is a list of common practices that help to support claims:

- **Keep careful records**. Make copies of everything. It's also a good idea to take notes during any meetings and conversations you have with your agent, insurer or claims adjuster.

- **Verify the adjuster's estimate**. Don't accept an estimate without getting a written bid from another contractor.

- **Don't settle for an unfair settlement**. If you can't reach an agreement with your adjuster, contact your agent or the insurer's claim-department manager. If you're still dissatisfied, some state insurance departments offer mediation ser-

vices. In addition, most policies allow for an independent appraisal or arbitration process to resolve disputes over money. That decision is usually binding.

- **Keep track of when your premium is due and the expiration date of your policy**. If you're late paying a renewal you may find yourself in a lot of trouble.

The easiest way for an insurance company to deny a claim is to show that the policy wasn't in effect when the loss occurred.

Of course, the issues aren't always so clear. If a loss occurs **just before the expiration date** of the policy and **continues** for two months afterward, the loss would be fully covered. However, a dispute could arise over when—exactly—the loss first occurred.

Example: You make a claim that, because of an insured flaw in the construction of your house, a series of accidents began during the policy's coverage period and has continued afterward. If the insurance company can show that the loss didn't begin and continue—but is, in fact, several losses occurring independently—it can limit its liability to claims that relate to accidents that occurred during the policy period.

CONCLUSION

If you have chosen your insurance effectively, making a claim will be pretty straightforward. Of course, the circumstances leading up to a claim—burglary, fire or other disasters—can make even the most calm mind nervous and edgy. This chapter has focused on the effective measures to take when making a claim.

Next up: Common problems with it comes to renting and dealing with renters insurance. If you run a small business from home, this next chapter is for you.

8

UMBRELLA COVERAGE'S SAVING GRACE

Sometimes a basic—or even a rider-stacked—renters policy just isn't enough to cover you for when something really bad happens. You could be sued for millions of dollars or actually have a great deal of assets that no basic renters policy will cover you completely. If you can't afford to lose more than what your current policy covers, maybe you should consider a **personal umbrella policy**.

As the number of outrageous tort lawsuits and punitive damages continues to rise throughout the country, the popularity of personal umbrella insurance policies continues to grow.

"The more people read the papers, the more they become concerned about their own exposures," says one New York-based insurance agent. And you don't have to be deep-pocketed to begin to worry. Even a poor graduate student could be sued for millions, lose his defense and be forced to give up future income.

Take, for example, one couple's experience:

Tom and Cindy Snell lived in a small one-bedroom apartment when some bad luck hit them. In the middle of the night, while they were sound asleep, the shampoo caddy fell from the showerhead and hit the faucet on its way down. Water started to pour out and fill the tub. The drain had always been slow, and within an hour the entire apartment was under an inch of water. Even though the couple had the floors dry within a couple of hours, the damage had been done. The parquet hardwood floors buckled and cracked later the next day. When the floor companies arrived, they all agreed: the floor needed to be replaced and it would cost $7,000.

The landlord expected Tom and Cindy to pay that $7,000, claiming that they were negligent and thus responsible. Unfortunately for the Snells, they didn't have a renters policy and even if they did, it might not cover this situation (i.e., water damage or "surface water"). The only thing they did have going for them was the fact that the apartment below them wasn't damaged.

What could they have done differently to prevent having to pay $7,000? If they had some sort of liability coverage in a renters policy, there could have been money there to cover this mishap. What's more, there's no deductible when payments come from liability coverage. If there was no renters policy, however, an umbrella policy professionally could have kicked in.

This is why the extra liability afforded to you through an umbrella policy can be critical.

After you have conducted an inventory of all your personal assets and find that your assets are much

greater than the liability limits of your renters policy, you may want to purchase an additional "umbrella" policy that will extend your liability coverage to $1 million, $2 million and sometimes even $5 million or more.

As we've seen, the **liability limit** on a policy is the maximum amount that will be paid for any one **occurrence**. (An occurrence is defined as an accident or a continuous or repeated exposure over a period of time that causes a loss or injury.) Liability judgments can exceed the liability limits of your policy. After these limits have been exhausted—you may be forced to pay with your personal assets. If the costs of a lawsuit go over your policy's limit, an **umbrella policy** starts paying.

Umbrella policies, designed for both individuals and businesses, were first written to serve two major functions:

- to provide **high limits** of coverage to protect against catastrophic losses; and

- to provide **broader** coverage than underlying policies.

An umbrella policy will protect you if someone sues you.

Typically, these policies are purchased by high paid professionals like executives, doctors, dentists, attorneys, etc. But don't assume that you don't need this coverage. Lawsuits are constantly increasing in frequency and severity.

An umbrella policy is written to provide you with liability insurance on an **excess** basis, above underlying insurance or a **self-insured retention** (a layer of losses absorbed by you).

The amount of this coverage usually ranges between $1 million and $10 million.

> Umbrella policies are not standard contracts and vary depending on the insurer. Some umbrellas are written to "follow form," meaning they don't provide broader coverage than the primary insurance. However, many are written to fill coverage gaps by providing coverages not included in the underlying insurance.

For losses that are covered by your primary policy, the umbrella coverage would begin to kick in only after the primary coverage is exhausted by payment of the **per occurrence** or **aggregate limit**. For losses that are covered by the umbrella and not by the primary policy, the umbrella coverage begins to apply after a loss exceeds an amount which the insured has agreed to retain.

The intent is to provide affordable, comprehensive coverage in case of a catastrophic loss, incidental exposure, and a modest gap in coverage, but not to provide blanket all-risk coverage in multiple areas where there is no primary insurance. For this reason, underwriters usually require an adequate range of underlying coverages for known exposures (personal liability, automobile liability, etc.), before providing you

with umbrella coverage. To a certain degree, the exclusions and limitations of an umbrella often follow the underlying policies. However, the umbrella will usually have fewer exclusions than the primary coverage, less restrictive exclusions and a broader insuring agreement.

A consistent problem with umbrella coverage is that policyholders try to use it as a cure-all for insurance problems. Umbrella coverage doesn't protect you from every risk in the world—it is excess insurance for whatever primary liability policies you have.

An umbrella policy offers a broader coverage than your homeowners policy. In addition to bodily injury and property damage, an umbrella policy covers false arrest, wrongful eviction, libel, slander, defamation of character and invasion of privacy.

PERSONAL UMBRELLA POLICY

Before your personal liability policy goes into effect, your insurer will typically require that all known major exposures be covered by any underlying policies that you may have and that each major exposure is declared in the umbrella policy with a premium shown.

For example, most people are required to have automobile insurance and a homeowners or renters policy for family automobiles and the residence exposure. These exposures must be declared in your umbrella policy.

> If you own a boat and it is not declared, there will
> be no umbrella coverage for the boat exposure even
> if it is covered by an underlying boatowners policy.

The declarations also show the total policy premium
and the limit of liability that applies. For example, if a
limit of $500,000 is shown for umbrella coverage,
that is the amount of insurance being provided in
excess of the underlying coverages.

If the insured maintains underlying auto insurance on
a **split limit basis**, then the deductible amount appli-
cable to auto liability will be $250,000/$500,000 bodily
injury and $25,000 property damage.

Types of Liability	Deductible Amounts Per Occurrence
Auto	$300,000
Personal	100,000
Recreational Motor Vehicles	100,000
Watercraft	100,000
Business Property	100,000
Business Pursuits	100,000
Employers Liability (where Workers' Compensation is required by law)	100,000
Loss Assessment	50,000

These limits are the minimum underlying limits for
various required coverages. Automobiles must usu-
ally be insured for a single limit of at least $300,000

per occurrence (split limits are also permitted). Most other exposures must be insured for a limit of at least $100,000.

> Note: The umbrella policy will only pay amounts in excess of these limits even if the underlying company becomes bankrupt or insolvent. An example: If you are held liable for $350,000 in damages resulting from an automobile accident and the auto insurance company becomes bankrupt, the umbrella policy will only cover $50,000 of the loss (the amount in excess of the deductible).

A special $1,000 deductible amount (also known as a "self-insured retention") applies to claims arising out of exposures which are covered by the umbrella policy but are not covered by the underlying insurance for some reason.

> An example: You're using your car and utility trailer to haul two large and valuable pieces of furniture for a friend. An accident occurs, the furniture is destroyed, and the friend sues for damages. Your personal auto policy excludes coverage for property being transported by you, but there is no such exclusion in the umbrella policy. This loss would be covered by the umbrella and the $1,000 deductible would apply.

An umbrella policy provides coverage on an excess basis for personal injury liability and property damage liability.

PERSONAL INJURY LIABILITY

Under an umbrella policy, the term "occurrence" means an accident, but it also includes continuous or repeated exposure to the same conditions. An example: Your hot tub leaks water, which travels over to your neighbor's unit and damages her belongings. Even though the leakage happens over the course of a week when your neighbor is away on business, the damage is treated as one occurrence.

For personal injury coverage (libel, slander, etc.) the term "occurrence" means an offense or series of related offenses. If you slander someone repeatedly on various occasions, it would be treated as a single occurrence if a personal injury claim were made. Since the offenses were related, the limit of insurance would not apply separately to each offense.

The **personal injury liability** policy covers your liability for personal injury. Personal injury includes bodily injury, sickness, disease, disability, shock, mental anguish and mental injury. The definition can also be extended to include: false arrest and imprisonment, wrongful entry or eviction, malicious prosecution or humiliation, libel, slander, defamation of character or invasion of privacy, and assault and battery not intentionally committed or directed by another insured.

If you commit any of the actions specified in this section, it could lead to a "personal injury" claim (no-

tice that this term does not have the same meaning as bodily injury).

SPECIFIC LIABILITY ISSUES

False arrest claims are usually based on damage to a person's reputation when a suspected wrongdoer has been arrested without proper cause. False arrest may result from mistaken identity or an error in judgment. **False detention** or **imprisonment** restrict a person's freedom of movement, and can lead to a claim for damages.

Malicious prosecution generally occurs when a person brings charges against another without a probable cause to believe that the charges can be sustained, and there is a malicious intent in bringing the charges.

Libel is the defaming of another by writings, pictures or other publication which is injurious to the person's reputation. **Slander** is oral defamation of others which is injurious to their reputation. **Defamation** is the holding up of another to ridicule, and includes libel and slander.

Invasion of privacy is the publicizing of another's private affairs for which there is no legitimate public purpose, or the invasion into another's private activities which causes shame or humiliation to that person.

Wrongful eviction is depriving a tenant of land or rental property by unjust, reckless or unfair means.

Wrongful entry is the resumption of possession (repossession of real estate) by an owner or landlord of real property by unjust, reckless or unfair means.

PROPERTY DAMAGE LIABILITY

Under a property damage liability policy, your insurance company pays for personal injury or property damage for which you are legally liable and which exceeds the **retained limit**.

A retained limit can be either:

- the total applicable limits of all required underlying contracts and any other insurance available to an insured, or

- the self-insured retention if the loss is not covered by any underlying insurance.

Property damage means physical injury to, destruction of or loss of use of tangible property.

Property damage includes loss of use. If you damage your neighbor's place, your neighbor might have to live somewhere else while the home is being repaired or rebuilt. The extra expenses for loss of use (rent, meals, transportation) could be claimed in addition to the actual damages to the home.

ODDBALL COVERAGES

There are a variety of situations for which an umbrella policy will be your saving grace—so long as underlying coverage already exists. Examples include using a company car or letting someone ehe drive your boat. An umbrella policy will cover you on an

excess basis while using a non-owned auto, only if the use of that auto is covered by underlying insurance.

> An example: You work for Mary Kay Cosmetics, which provides you with a car for use in your sales work. As long as your employer's policy provides at least $300,000 of coverage for your use of the company-owned car, your umbrella policy will provide additional coverage.

Family members are insured for their use of owned autos, or autos furnished for their regular use, only if their use of such autos is covered by the required underlying insurance.

Example: Mr. and Mrs. Jones have a personal umbrella policy and their teenage daughter lives with them. The daughter has her own car. The umbrella policy will cover the daughter's use of the car if she has personal auto coverage with a limit of at least $300,000.

For autos or boats owned or in your care, any other person using such items, or any person or organization responsible for the acts of someone using such items, would be insured.

If your son lets a friend drive the family speedboat, the friend would be considered an insured person. If he uses your boat to teach members of his son's Boy Scout troop to water ski, the Boy Scout troop would be considered an insured person.

For animals owned by any family member, any other person or organization responsible for the animals is an insured person.

An example: While on vacation, you leave the family dog with a neighbor who has agreed to take care of it. If the dog breaks loose and bites a jogger, the umbrella policy would cover the neighbor as an insured person if the neighbor is sued for the injury.

None of the following is considered an "insured" under this policy:

- the owner or lessor of an auto, recreational motor vehicle or watercraft loaned to or hired for use by an "insured" or on an "insured's" behalf;

- a person or organization having custody of animals owned by you or a family member in the course of any business or without the consent of an insured.

An example: If you rent a boat for fishing, the boat rental company will not be considered an insured person under this policy (it should have its own liability coverage).

Another example: If your daughter owns a horse which is boarded at Sunset Stables for a fee, the stable will not be considered an insured person under this policy (it should have its own liability coverage).

WHAT'S COVERED?

Umbrella policies provide **legal liability insurance**. This means that the coverage applies only if you're

found to be legally responsible for one of the types of injury or damage insured against. Covered damages include pre-judgment interest.

The duty to defend a claim ends when the insurance company has paid damages equal to its limit of liability.

If laws prevent the insurance company from defending you, it will pay expenses for defense which are incurred with its written consent.

In addition to the limit of liability, your insurance company pays:

1) All expenses incurred and costs taxed against an insured.

2) Premiums on required bonds, but not for bond amounts more than the limit of liability. You need not apply for or furnish any bond.

3) Reasonable expenses (other than loss of earnings) an insured incurs at the insurance company's request.

4) An insured's loss of earnings, but not other income, up to $100 per day, to attend trials or hearings.

When your insurer defends a claim or suit, it will pay all of its own expenses and reasonable expenses incurred by you at its request. But coverage for your loss of earnings while attending trials or hearings is

limited to $100 a day. The insurer will also pay premiums for required bonds and post-judgment interest.

Your insurer will pay for your share of the **loss assessment** charged during the coverage period against you, as owner or tenant of the residence premises, by a corporation or association of property owners. The assessment must arise from an occurrence covered by the policy and applies only to assessments in excess of the "minimum retained limit."

If you're an owner or tenant of a condominium unit, the umbrella policy will pay your share of loss assessments charged against you by the condominium association. Loss assessments against individual unit owners are often made when the condominium association is held liable for a loss that exceeds the limits of its liability insurance, or is not covered by its policy.

> **Beware of changes in your liability exposure throughout your life. Your liability exposure can be increased by certain lifestyle factors, such as travelling or entertaining a lot, operating a home-based business or having teenagers who drive. Periodically reexamine your liability coverage to be sure that it is appropriate and current.**

EXCLUSIONS UNDER UMBRELLAS

Exclusions appear in insurance policies to shape and limit the coverage to what is intended by the contract.

In some cases, exclusions apply to exposures that are not insurable. In other cases, exclusions apply to exposures that should be covered by another kind of policy.

Coverage under an umbrella policy is excluded for an act committed by or at the direction of an insured with intent to cause bodily injury or property damage. This does not apply to bodily injury or property damage resulting from an act committed to protect persons or property, or to prevent or eliminate danger in the operation of an auto or watercraft.

Because insurance is designed to cover **accidental and unexpected losses**, intentional acts of an insured person are not covered. But a few exceptions are made for situations where an insured person acts with the intent of protecting persons, property or preventing a greater loss.

An example: An injury caused by use of a weapon against a criminal who intends to rob and injure another would not be excluded.

Another example: If your car's brakes fail and you purposely drive the auto into a building in order to avoid hitting children crossing the street, the damage to the building would not be excluded.

UNLAWFUL ACTS

Personal injury losses resulting from an insured person breaking the law are excluded. The intent of this provision is similar to that of the exclusion of intentional acts.

Since this is a personal umbrella policy, business exposures are generally excluded, however, exceptions are made for incidental exposures, and for business exposures that are declared and covered.

Activities that are common non-business activities are covered, even if related to your business.

An example: While playing golf with a customer, an insured salesman hits a long drive and the ball hits another golfer on an adjacent fairway and causes injury. This accident would not be excluded because playing golf is a "non-business" type of activity.

No liability coverage is provided for a person who uses your vehicle or boat without reasonable authority to do so.

An example: If a person steals your boat and causes an accident, the thief would not be covered by the insured's umbrella policy if sued for damages (the insured would still be covered if sued as the owner).

Another example: If a neighbor has used your boat on numerous occasions, and has been told that it may be used whenever it is not being used by a family member, the neighbor would be insured for use of the boat. This is true even if an accident occurs at a time when you have no knowledge that the boat is being used.

The only racing exposure that is covered is sailboat racing. Coverage is not provided for racing vehicles or motorized boats, or while practicing for a race.

> Liability insurance is known as "third party" cover-
> age, because it is designed to pay damages suf-
> fered by others when you are responsible. For this
> reason, injuries suffered by you or family members
> are not covered.

This provision was added in recent years following a number of claims for damages due to the transmission of diseases such as herpes and AIDS among family members. Some courts required insurance companies to pay these damages under personal liability policies. Liability arising out of the transmission of a communicable disease is now excluded.

Similarly, there is no coverage for property owned by you, or by an association of owners of which you are a member (such as the common property jointly owned by a condominium association). Coverage is also excluded for damage to property that is rented, used or occupied by you or in your care, but only to the extent that you have agreed to insure the property in a written agreement.

An example: You rent furniture and agree in the rental contract to insure it for a stipulated amount.

The umbrella policy will not provide coverage for that amount (it might provide some additional excess coverage). The property would be covered if there was no written agreement by you to provide other coverage (but the umbrella deductible will still apply).

A personal umbrella policy includes loss assessment coverage for owners of condominium units. When

bodily injury, property damage or personal injury occurs on the "common" premises (not within any owner's unit), a claim for damages may be made against the association. If the loss is not covered by or exceeds the limits of the association's liability policy, it would be necessary for the association to assess the individual owners for a proportionate amount of the loss. For this coverage, the term *occurrence* has the same meaning as it does for other liability coverages, except that it also includes acts of directors, officers or trustees of the association.

Note: If you are serving as an officer of a corporation or member of a board of directors, your acts are generally excluded from coverage because this is a professional liability exposure. But coverage is provided if you're acting for a nonprofit organization and receive no pay for services.

While the policy will cover some loss assessments made by organizations such as condominium associations, it will not cover assessments made by a governmental body against you or the association, nor will it cover an assessment made by the association to pay for a deductible which applies to an underlying policy.

LIMITS TO COVERAGE

Your insurer's total liability under your umbrella policy for all damages and loss assessments resulting from any one occurrence will not be more than the limit of liability as shown in the Declarations. The limit is the

same regardless of the number of insureds', claims made, loss assessments, persons injured, vehicles involved in an accident, or exposures or premiums shown in the Declarations.

Should two or more insureds, such as you and another family member, be sued, the policy will provide a defense for each insured. However, the limit of liability for all damages arising out of one occurrence remains unchanged.

An insurance company is entitled to appeal any judgment that could result in a claim payment being made under the umbrella policy. This is true even if you or your insurance company providing underlying insurance elects not to appeal the judgment. If it appeals, the insurance company will **pay all costs related to the appeal**.

If you become bankrupt, the umbrella policy still applies on an excess basis over the applicable deductibles. The umbrella will not become primary coverage due to a lack of underlying insurance or your inability to pay the deductible.

CONCLUSION

If you are in need of broader coverage than what your renters policy has to offer, you may want to consider an umbrella policy that provides separate coverage over and above any underlying insurance that you may have. Ask you current carrier about getting this coverage if you're interested. Having multiple policies means premium discounts.

Chapter 9, our last chapter, will fill in all the remaining blanks for renters insurance.

CHAPTER

9

ODDS AND ENDS
TO RENTING

There are still many unresolved issues when it comes to renting and renters insurance. We hope by now you've got an idea about what renters insurance is and what it can do for you as a tenant on someone else's property. It's **no longer a luxury** to have insurance; it's a necessity no matter how many assets you have or what you think you're worth. Things bad can happen at any time—costing you more than you can imagine.

In this chapter we'll finish the topic by looking at a few more issues related to renting. Chief among these: insuring and maintaining a home-based business; and being a good tenant.

HOME BUSINESS

Many people don't think about insuring their home business if it's secondary to an office away from home. If you start a small jewelry-making business, for example, in an extra room or if you do **freelance dot.com work** in an at-home office, your basic renters policy won't cover you entirely.

A "business" is defined as any trade, profession or occupation. If you start a catering business from home and a grease fire starts in the kitchen when you're getting a meal ready for a party, you may have problems filing a claim. Some policies specifically exclude *any* home-business claims.

Home-based consultants, artists, computer programmers, dot.comers, graphic designers, tutors, teachers, architects, writers and anyone else with a traditional office at home are at risk. If you maintain a home office for an outside job, like many lawyers, doctors, accountants, contractors, plumbers, photographers and designers do, you are at risk. If you receive any packages related to your business or **meet with clients** in your home, you are doubly at risk. Anyone who is hurt while on your premises can hold you liable.

A basic policy will limit the coverage for business property to $5,000 if located on the premises, and $1,000 for when it's away from the residence. Neither does a basic policy cover any business property:

- in strorage;
- held as a sample; or
- held for sale or delivery after sale.

Business documents, records or data regardless of the medium on which they exist are also excluded from basic coverage.

The limitations, however, to business coverage in a basic renters policy are even stricter with regard to

liability. In some policies, **liability coverage falls to zero** when it's related to a business. Under Liability Losses We Do Not Cover you might find:

> Personal liability and medical payments to others do not apply to bodily injury or property damage arising out of business pursuits of any insured...and arising out of the rendering or failing to render professional services.

This exclusion does not apply to:

- activities that are ordinarily incident to non-business pursuits (e.g., inviting the FedEx guy in for a cup of coffee, who later gets sick from your tainted Joe);

- personal liability for the occasional or part-time business pursuits of any insured who is under 23 years of age; and

- the rental or holding for rental of a residence of yours on an occasional basis for the exclusive use as a residence, in part, unless intended for use as a residence by more than two roomers or boarders, or in part, as an office, school, studio or private garage.

If you run a business from home, you need to consider getting a **home business policy**, which is just as affordable as a renters policy. Don't think that your home policy will cover you sufficiently for when something goes wrong related to even the smallest business. The second you do business in your home, your insurance coverage can drop by tens of thousands of dollars. If a fire destroys your home office, the $20,000

worth of computers, scanners, printers, fax, phone, furniture, documents, books and files won't be covered by your renters policy. You'll be able to collect the policy's limit, which is usually $5,000. Even if you had purchased a rider for that expensive computer, it may not come into play when your insurance company finds out that you had been using that computer for **business pursuits**. What's worse, many renters policies limit coverage for stolen or destroyed business property to a comically low $250 when you're away from home.

ENDORSEMENT OR A POLICY

There are two ways to cover a home business: adding an **endorsement** to an existing policy or buying a standalone business policy. Deciding which is right for you depends on how much you have to cover.

The cheapest way to increase your business coverage is to add an endorsement to your renters policy. For some, this could mean less than $100 a year, raising your business property and liability limits to the same level as the rest of your coverage.

For example: Suzie launches an interior design firm in her home after working as an associate in a big NY firm. She doesn't have much (a computer, printer, desk and some design materials), but enough to need an endorsement to her $350 a year renters policy. So, she pays an extra $75 a year and gets $50,000 worth of business property and $300,000 of liability coverage. This covers her for any mishap that occurs resulting from her business activities,

> such as someone getting hurt in a slip and fall while
> in the course of business.

Business endorsements will cover most small at-home businesses, but sometimes they don't cover enough. You may start with an endorsement and eventually need a separate business policy once things get going and you acquire more assets or see more clients. Every growing business generates **new risks**.

Some insurance companies will tailor a business policy to your specific needs. And some write different policies depending on whether your at-home business is the **primary** business or merely a **secondary** business.

> Describe the nature of your business to your insurance agent, how much space your office occupies, how many business-related assets you have and how often you see other people related to your business. Your agent can best tell you whether you need a simple endorsement or a more complete business policy.

If you find it difficult to find an insurance company to write you an at-home business policy, keep looking. Some companies, like The Hartford, will write a so-called **Home Business Insurance Plan** for you. And, make sure you specify that you are a renter. Although it shouldn't matter whether you're a homeowner or a renter when it comes to business cover-

age, you may need to do some more research to find a company that will tailor an at-home business policy for renters. You may also need the **approval from your landlord,** since the landlord is the property owner.

Business policies can cost anywhere between $200 and $1,000 a year. A $200 policy can get you around $5,000 in personal property and $300,000 in liability coverage. But every policy will differ and it will depend on exactly what you're insuring. You can always up your limits with higher premiums.

> If you're a therapist, accountant, dentist, doctor or anyone who renders professional services for which customers pay a fee, you'll need to look into obtaining professional liability insurance. Business policies do not typically cover business liability, sometimes called errors and omissions or malpractice insurance. This is a very specialized type of insurance, and has become increasingly more important (as well as expensive). Because few people provide services of this kind out of their home, we exclude this type of insurance. Ask your agent for more information.

BOPs

Business owner policies (BOPs) cover business property and liability. The standard BOP covers your legal liability for damages because of bodily injury or prop-

erty damage, and it also covers **personal injury** and **advertising injury** (injury arising out of libel or slander, among other things, in the course of advertising goods, products or services). The insurance company provides defense costs and the standard set of supplementary payments found on liability policies (i.e., cost of bail bonds settlement expenses, loss of earnings, prejudgment and postjudgment interest on amounts awarded).

In a BOP, the **medical expense** insurance covers expenses for bodily injury caused by an accident on premises you own or rent, including the ways next to such premises, or an accident because of your operations. Medical expenses incurred within one year of the accident date are covered, and payments are made without regard to fault or negligence.

The businessowners liability form includes a long list of exclusions. In total these are similar to the combined exclusions applicable to bodily injury and property damage liability, personal injury, advertising injury and medical payment coverages found on commercial general liability forms.

You should be aware of the types of exclusions applicable to these coverages. Some of the exclusions are complex and very detailed. Some are exotic, like the clause that excludes damages caused by war or nuclear materials. The following is a brief glance at a few of these exclusions:

- bodily injury or property damage expected or intended by you;
- liquor liability;

- obligations under workers' compensation, disability, unemployment, etc.;

- bodily injury to any employee arising out of and in the course of employment by you;

- pollution liability;

- bodily injury or property damage arising out of any aircraft, auto or watercraft;

- bodily injury or property damage arising out of the transportation of mobile equipment;

- professional liability;

- property damage (to your work, product or other);

- damages claimed for any loss, cost or expense because of loss of use, withdrawal, recall, repair, removal or disposal of your product, work or impaired property;

- various personal or advertising injuries (slander, libel, defamation, etc.);

- medical expenses for bodily injury to you, an employee or tenant;

- medical expenses for bodily injury to any person if the bodily injury is covered by a workers' compensation or disability benefits law or similar law; and

- medical expenses for bodily injury to any person injured while taking part in athletics.

Again, this list is a mere glance at the exclusions to coverage. Read your BOP carefully and know what is and isn't covered. If your home-business is related to a product, make sure there's nothing "toxic" about it. You may be left high and dry if someone sues you for shipping a toxic brew of your Pale Ale and you can't get your BOP to cover you.

> Remember: Any home-based policy, whether added to your basic renters policy or on its own in a BOP-type policy, won't cover the non-business related items and the liability related to those things. If you opt for a BOP, you must also obtain a basic renters policy to ensure that all of your assets and potential liabilities are covered.

A business policy usually covers additional mishaps such as damage to your equipment caused by power surges and loss of income if you suddenly can't work because your office is destroyed. Some policies will cover valuable papers, mechanical breakdowns and employee malfeasance.

> Note to Renters: Check with your landlord about your home-based business before you even begin! Many landlords don't allow tenants to operate businesses out of their apartments for fear of the new liability they carry. Check your lease agreement for any clauses that stipulate rules for home-based businesses. You don't want to face eviction the moment your start-up gets going.

If you have employees, you may need to provide **workers' compensation insurance**. This covers medical bills and lost wages for anyone hurt on the job. You may be required by state law to provide workers' comp insurance, so ask your agent. Most BOPs don't include this kind of insurance, so you'll have to obtain it separately.

For more information regarding business policies, your insurance agent is your best bet. Issues related to home-based businesses, no matter how small, can grow complex. For the most part, an endorsement or a BOP is the best tool for covering you; however, **commercial general liability** (CGL) policies and **business umbrellas** are other tools to consider under certain circumstances. Only you and your insurance company can determine which mechanism is best for you.

DISCOUNTS

We've mentioned this before: purchasing **multiple policies** with your insurance company usually means breaks in insurance premiums. If you have a personal auto policy, ask your auto carrier about renters insurance and the discounts for having two policies. You can also take advantage of discounts related to **volume buying** if your management office or your building offer a tenant policy. You will pay less for coverage if the same company offers renters insurance to all who want it in the building. Other things that can discount your premium payments:

- Fire department location: Is it less than five miles away? One mile away?

- Security system: Do you have a security system connected to a central station?

There's no discount for the location of the fire hydrant or the placement of smoke detectors. The insurance company expects these things to be in proper place.

LANDLORD-TENANT LAW

A body of laws from both state statutory and common law exist to protect you and your landlord. Many states base their statutory law on either the **Uniform Residential Landlord and Tenant Act** (URLTA) or the **Model Residential Landlord-Tenant Code**. Federal statutory law may come into play during a national/regional emergency and in preventing forms of discrimination.

As a renter, you have rights and responsibilities, as well as a legal relationship with your landlord, which is grounded by contract and property law. You have a property interest in the land for a given period of time—whether that period is indefinite or definite. Most leases are renewable/cancellable on a month to month basis and cancelable by either party with notice. If you turn in your rent check every 30 days (monthly) then you must give 30 days notice of plans to vacate; if you pay the rent every two weeks, then two weeks is sufficient notice. In many cities, you must sign a 1-year lease before going month-to-month. This protects the landlord from the costs associated with people who move every couple of months. Similarly, you have rights with regard to:

- nondiscrimination;

- rent increases;

- complying with the rules and guidelines that govern your lease;

- not engaging in criminal activity while on the premises;

- maintaining you unit; and

- relocation assistance when displaced from your home by the government.

This last item doesn't happen often. But if federal funds are used to come in and demolish your apartment building (for some covert operation) **the U.S. Department of Housing and Urban Development** will come to your rescue, assisting in your relocation.

A landlord-tenant agreement is usually embodied in a lease. The landlord-tenant relationship is founded on duties proscribed by either statutory law, the common law or the individual lease.

Make sure you carefully **review your lease** before you sign. A landlord may add several conditions to your lease (i.e., overnight guests, home businesses, design alterations) that don't agree with you. Never seal a deal without understanding the terms to your contract. And always get everything in writing to avoid costly disputes.

Basic to leases is the implied **covenant of quiet enjoyment**, or the agreement that ensures you will not

be disturbed by someone with a superior legal title to the land (i.e., you won't be harassed by your landlord). And you, as a legal tenant, have a duty to pay rent and abide by the rules of your contract. **Housing codes** exist also to protect both you and your landlord. Such codes make sure that your rental unit remains habitable during tenancy. For example, landlords are required to offer adequate weatherproofing; heat, water and electricity; and clean, sanitary and structurally safe premises. If you think your unit is not habitable, and you've made this known in writing to your landlord, there are courses of action you can take. But proper ways of handling situations may depend on the state where you reside, or the terms in your lease. You may be able to withhold rent or move out without liability for future rent. A good place to start searching for housing help, contact HUD:

U.S. Department of Housing and Urban Development (HUD): 451 7th Street S.W., Washington, D.C. 20410; Telephone: (202) 708.1112; TTY: (202) 708.1455; Web site: *www.hud.gov.*

You can also find your local public housing agency by phone. Just contact the housing counseling agency closest to you or call toll-free 1.888.466.3487 or log onto HUD's Web site.

PICKING A PLACE

There are a few other things you should know when it comes to renting—and it starts with choosing a place to live and paying rent. With the possible exception of taxes, housing is usually your **single biggest expense**—so it makes sense to do a lot of looking before you choose a place to live. The competition for

rental units these days can be tight, enough that you have to fill out a rigorous application and meet certain requirements before a landlord will approve of your tenancy. Many places won't give you an application unless you bank more than three times the cost of rent. In general, it's a good idea to approach apartment hunting with an eye on your wallet. Housing should not exceed **25 to 30 percent** of your take-home pay. If you live in a bustling city, like L.A. or New York, this kind of budgeting is tough.

The following is a general list of where your money should be going:

25 to 30 percent on HOUSING
8 to 15 percent on FOOD
5 to 7 percent on HEALTH CARE
7 to 9 percent on INSURANCE/PENSIONS
6 to 8 percent on CLOTHING
5 to 9 percent on ENTERTAINMENT
6 to 10 percent on GENERAL SAVINGS

--

62 to 88 percent TOTAL SPENT

The remaining 38 to 12 percent? Think about the other **incidentals like transportation,** eating out more than usual, credit card debt, school loans and emergency needs (like paying a deductible for a car accident or surgery). Just makes sure you don't sign a rental agreement for a place that's too expensive. Otherwise, you won't be able to pay your bills or your next rent check.

The average American spends too much on many incidentals, such as eating out for lunch and dinner, stopping for a designer coffee on the way to work, buying chichi gadgets or leases on fancy cars. Don't overestimate your financial abilities. Always keep in mind the "hidden" costs to living, the payments on things that can add up quickly but which are necessary to life. Some of these include utilities, water, trash removal, cable and phone. Prior to moving into a unit, you'll have to cough up a **security deposit** (anywhere from $100 to a full month's rent), a credit check fee, first and perhaps last month's rent, as well as a deposit for your pet if you have one.

> According to *The Millionaire Next Door*'s Thomas Stanley and William Danko, a rental payment should be no more than half the realized income, or the income after taxes. Most go further and suggest that it be only 25 to 30 percent of take-home pay.

You can **minimize housing costs** by considering roommates, unhip areas, subletting or offering managerial services to your landlord in return for a discount on rent.

In addition to your application, you must have a good credit history and written references from previous landlords, your employers, friends and colleagues. Having all these things in check and ready to go will help you find a place to live quicker. Potential landlords may run **background checks** on you to ensure that you've never been convicted of a felony or been evicted.

A NOTE ABOUT CREDIT

It's a very important to **obtain your credit report** prior to entering a rental agreement. You don't want the hassle of applying for an apartment and then be denied for having poor credit. If there's an error in your report that may affect your ability to get an apartment, you'll want to know about that error first. Even if your credit isn't stellar, there are things you can do to make it better and prove that you can pay rent. But you need to know where you stand.

If you've had problems in the past **paying your rent on time**, this may be reflected in your report—even if an unreliable roommate left you without paying his half of the rent, and you didn't make up the difference.

In addition to your debts and payment history, credit reporting agencies also provide: general data (name, Social Security number, marital status, addresses—past and present); employer's name and address; inquiries of your credit file; and public record information like bankruptcies and liens.

Credit reporting agencies do not, however, maintain files regarding your race, religion, medical history or criminal record—if you have one.

Where to go: You can obtain a credit report from any of the three main credit reporting agencies: Experian, Equifax and Trans Union. Typically, these companies do not contain identical information, so it's worth your while to order all three:

- Experian: (800) 685-1111 *www.experian.com*;

- Equifax: (888) 397-3742 *www.equifax.com*; and

- TransUnion: (800) 916-8800 *www.transunion.com*.

Other online credit reporting agencies that say you can receive your history in 30 seconds will mail an official, reliable report within a week. Several Web sites also provide information on credit reporting, how to read a credit report, federal privacy laws and other technical questions.

Several **online credit data companies** boast about their ability to provide your credit report—in its complete form—for free. Be wary of these offers. The sites query the same companies that you can query—without the potential damage to your credit rating. Always remember that your ability to pay rent affects your credit report. If you default on your rent payments, your landlord may report you, which can have long-term effects. If you consistently forget to pay rent, you'll have a hard time finding other places to live. And, if you hope to purchase a home someday, having a good and consistent rental history will aid your ability to secure a mortgage loan from a bank or other financial institution.

ABOUT FICO SCORES

In this information-based economy, FICO scores are **critical personal information**. Philosophically, this may be a questionable thing: practically, it's an essential thing to know. FICO stands for Fair, Isaac and Company, which develops the mathematical formulas used to obtain snapshots of your credit risk at a

given point in time. These scores are the most widely used and recognized credit ratings. FICO scores are calculated by the three major credit reporting agencies, but they are called BEACONs at Equifax and EMPERICAs at Trans Union and Experian.

Factors that determine your FICO score (from most to least important):

- payment history;
- amount owed;
- length of credit history;
- new credit; and
- types of credit in use.

Following these factors, the ways in which you can **improve your score** include:

➡ paying down your revolving account balances;

➡ letting your credit history age;

➡ paying off your debt; and

➡ applying for credit only when you need it.

A FICO score is based solely on the information in your credit report, so who your employer is, how much he pays you or what he has to say about you does not reflect this score.

Note: Searching for "free credit score" on the Web opens the door to several lenders and banks willing

> to give you your score. Some may require you to
> apply for a loan first, and some scores aren't reli-
> able. It's advisable to fork over the couple of bucks
> for a genuine report and score.

For more about your FICO score, visit *www.myfico.com*.

CHANGING YOUR ARRANGEMENT

If you already have an apartment and you're having
trouble making ends meet, you may want to **con-
sider taking on a roommate**. This may be inconve-
nient if you're in a studio apartment, but even a small
one bedroom can usually accommodate two people.
If your rent is too much to bear, and a roommate is
not practical, you are going to have to have a talk
with your landlord. I have a frank conversation in
which you explain that you are not going to be able
to afford the rent you are currently paying. Most land-
lords will work with you to come up with a solution.
You may want to explore the following:

➡ Ask for a decrease in the rent. A tempo-
rary decrease may be acceptable to your
landlord, who's likely to lose one or more
months of rent if you move out and the
apartment is temporarily vacant.

➡ Ask your landlord if there is a less ex-
pensive apartment available. You may be
able to move into something a bit
smaller, or in another building controlled
by the landlord.

➡ Explain to your landlord that you are go-
ing to have to move out of your apart-

ment. Ask if you can help find a new tenant, provided that your landlord will let you out of your lease.

➡ Offer to work in exchange for a rent reduction. Most apartments and apartment buildings have odd jobs that need to be done—from cleaning the carpets to painting the halls. In many situations, the landlord dreads having to spend the time and money required to do more than just basic maintenance. You may be able to take on a few of these tasks for a break on your rent.

Whatever approach you take, keep in mind that your landlord simply wants to collect rent and deal with the **least amount of hassle**. Running an apartment building can be endlessly problematic. That's why landlords charge security deposits. And you want to avoid forfeiting your security deposit because you can't come to an agreement with a stressed-out landlord.

IMPORTANT TIPS FOR RENTERS

Before you sign a lease, make sure you've read and understand the whole document. Some landlords will try to slip all kinds of wacko terms and conditions into it, hoping you'll just skim over them. Pay particular attention to the following items:

- The **amount of rent** each month. Make sure it's the same amount you've agreed to in discussions.

- The **term of the lease**. The best term for a basic apartment lease is usually six months to two years. If you want to stay

longer, either ask for an option for more time or agree to convert to a month-to-month agreement.

- **Fees**. Check how much extra you'll owe if you're late on a payment, bounce a rent check or cause damage to the apartment. Some landlords put onerous terms on these events as an easy way to break a lease.

- Rules on roommates, **pets or children**. Many leases specify whether or not you can have any of these—most often they prohibit pets. Check with the landlord, if you want your girlfriend to move in with you. The landlord may not approve of unmarried couples living together or may want to charge you more for utilities, such as water or gas (if it is included in the rent cost).

- Any conditions pertaining to your **security deposit**. This issue is the single biggest problem in lease deals. Make sure you're clear on how the landlord can make charges against your deposit when you want to move.

Also, inspect the apartment carefully after you've agreed to rent but before you've moved in. Check the following:

- electrical outlets and fixtures for operating status;

- appliances, heating or cooling and ventilating systems for operating status;

- water pressure and drips or leaks in the bathroom and kitchen;

- windows for broken or damaged glass, sticking or jamming and security devices;

- doors for cracks, sticking or jamming;

- fire or burglar alarms and security systems for operating status;

- carpets or wood floors for damage, wear or stains;

- floors and walls for cracks, buckling or noticeable damage;

- panelling or molding for noticeable damage;

- mirrors or other decorative elements in windows, staircases, fixtures or anywhere else;

- balconies, decks or patios for usefulness; and

- any furniture or equipment being stored or offered for use.

Before you sign your lease, you have some leverage. Once you've signed the thing, you're just **another complaining tenant**.

Go out of your way to stay on good terms with your landlord. He or she can make your life difficult, and you may need a recommendation from her for your next apartment.

PUT THINGS IN WRITING

If your landlord agrees to change any of the terms of your lease, make sure to write it down in a letter and send it to your landlord. Start such a letter with "This letter is to confirm that we have agreed to the following: ...," and end with, "Unless I hear from you, I will assume that these terms are still acceptable to you." Although you are better off getting this letter signed by your landlord, this type of letter should be enough to protect you if your relationship sours.

As mentioned above, most states have laws controlling the rights of tenants. Regardless of what your lease says, these laws control things like how much of a security deposit and prepaid rent your landlord can require, how much they can take out of your deposit for damages, and how quickly they have to return your money after you vacate your apartment. These laws are usually favorable to tenants, and if they are not followed, the landlord may have to pay you **up to three times the amount** of the deposit.

Almost every state (and even some cities and/or counties) has a Department of Consumer Affairs, Tenant Rights Department or similar group, that will help you with problems with your landlord, and answer legal questions about your lease for free.

MOVING OUT

Before moving out, it's a good idea to **review your responsibilities** as a tenant as outlined in your lease agreement. You may not have realized until now that you weren't supposed to drill holes into your walls,

or that you'd be responsible for mildew, cracking and peeling wall damage as a result of hot showers combined with not using the overhead ventilation fan. Pay attention to clauses that relate to wear and tear. You hope to get back some—if not all—of your **security deposit**. You may want to have your floors and carpets professionally cleaned, for example, since this where most people seem to do the most damage. Sometimes, however, even that isn't enough as this next case demonstrates.

In *Jelinski v. Barr*, a Wisconsin man had a hard time getting back his security deposit and he took his former landlord to court in 1999. Thomas Jelinski moved into an apartment owned by Security Management Company (SMC) in June of 1997. He vacated the unit at the end of August the following year. He paid a $720 security deposit knowing that he'd be responsible under Wisconsin law for damages caused by the **negligence or improper use of the premises.**

Prior to his exit, Jelinski had the apartment carpets professionally cleaned and when he inspected the apartment with Karilyn Wallender, the assistant manager, he agreed to pay carpet stain repair damages for two small stains noted as stain "that cannot be extracted." Jelinski testified that he assigned the Incoming/Outgoing Inspection Form agreeing to pay $20 as a reasonable charge. This form, however, changed by the time it reached the trial court. At trial, the form included an assessment fee for "Sm. Red Spots" on the living room carpet, which Jelinski said wasn't included on the form he signed. According to Jelinski, "[t]he document that I signed, the outgoing inspec-

tion, was altered after my signature to make it appear that I agreed with the altered charges."

Wallender, on the other hand, said that she went back to the apartment the next day and advised Jelinski that the carpet was unacceptable. Jelinski provided another carpet cleaning, but to no avail. SMC later notified Jelinski that it would be retaining the security deposit of $720, assessing a carpet replacement cost of $1,300, and requesting that he pay the balance due of $580. Jelinski refused to pay and took SMC to court.

The trial court found in favor of Jelinski, agreeing with him that the agreed-upon carpet repair cost was reasonable. Although the form now stated a repair cost of $50 (assessment fee), the court couldn't determine if or when the change to the form was made. It took the document at face value. It also had to take into consideration two things set by state law:

- Damages are set at the smaller of either the cost of repairs or the diminution in the use of property; and

- When property is destroyed beyond repair, the usual measure of damage is the market value of the chattel at the time and place of destruction with adjustments for salvage value.

Thus, Jelinski would not be responsible for replacing the entire carpet. And, since the trial court found $50 to be a reasonable repair cost, the appeals court came to the same conclusion. Jelinski would get his security deposit back minus $50.

This case demonstrates the importance of **knowing your rights and responsibilities** as a tenant. The laws cut both ways. It most cases, it's not worth arguing over a security deposit in a small claims court. But, this is another reason to obtain a renters policy. It may come to use when you are found liable for damages. Watch out, however: read the terms to your lease agreement and renters policy closely to understand what negligence means and under what circumstances you can be held liable. When in doubt, ask your landlord or local housing board.

CONCLUSION

This book has talked a lot about the mechanics of renting and how a renters policy can protect you and your things from the mishaps of life. Surprisingly, few people ever think about renters insurance until something bad happens and someone says, "Do you have insurance?"

We've all seen the scenarios on the news. Apartment building burns, people are out on the street waiting to see if they have anything left. Many have to sleep somewhere else for days, maybe months, while they figure out how to put their lives back together after losing everything. If you don't think this can happen to you, think again. And then think about spending less than what you currently spend on lattes in a month for a simple policy that protects you and your possessions.

You now have the tools and the know-how to go and find a policy to fit your needs and lifestyle. There's no mystery about it. Do it for the peace of mind and for the security of your future. Good luck.

INDEX

20% Off Silver Lake Publishing books

Silver Lake features a full line of books on key topics for today's smart consumers and small businesses. Times are changing fast—find out how our books can help you stay ahead of the curve.

[] **Yes.** Send me a free **Silver Lake Publishing catalogue** and a 20% discount coupon toward any purchase from the catalogue.

Name: _____

Company: _____

Address: _____

City: _____ State: _____ Zip: _____

Phone: _____

Silver Lake Publishing · 2025 Hyperion Avenue · Los Angeles, CA 90027 · 1.323.663.9082

slpy

BUSINESS REPLY MAIL
FIRST-CLASS MAIL PERMIT NO. 73996 LOS ANGELES CA

POSTAGE WILL BE PAID BY ADDRESSEE

SILVER LAKE PUBLISHING
2025 HYPERION AVE
LOS ANGELES CA 90027-9849